Peter Birkhäuser
Light from the Darkness
Licht aus dem Dunkel

LICHT AUS DEM DUNKEL
DIE MALEREI VON PETER BIRKHÄUSER

1980
Birkhäuser Verlag
Basel · Boston · Stuttgart

LIGHT FROM THE DARKNESS
THE PAINTINGS OF PETER BIRKHÄUSER

1980
Birkhäuser Verlag
Basel · Boston · Stuttgart

Inhalt

17 Der Maler Peter Birkhäuser
 Einführung von Eva Wertenschlag und Kaspar Birkhäuser
27 Bildteil mit Kommentaren von Marie-Louise von Franz
121 Analytische Psychologie und die Probleme der Kunst
 (Vortrag von Peter Birkhäuser)
138 Bildverzeichnis

Contents

9 The Painter Peter Birkhäuser
An introduction by Eva Wertenschlag and Kaspar Birkhäuser
27 Plates and Commentaries by Marie-Louise von Franz
103 Analytical Psychology and the Problems of Art
(Lecture by Peter Birkhäuser)
139 List of Plates

CIP-Kurztitelaufnahme der Deutschen Bibliothek

Birkhäuser, Peter:
Light from the darkness: the paintings of Peter
Birkhäuser = Licht aus dem Dunkel. – 3. Aufl. –
Basel, Boston, Stuttgart: Birkhäuser, 1980.
 ISBN 3-7643-1190-8

Library of Congress Card Number
80-2675

© Birkhäuser Verlag Basel, 1980
Photolithos: Steiner + Cie AG, Basel
Design: Albert Gomm asg/swb
Printed in Switzerland by Birkhäuser AG, Basel
ISBN 3-7643-1190-8

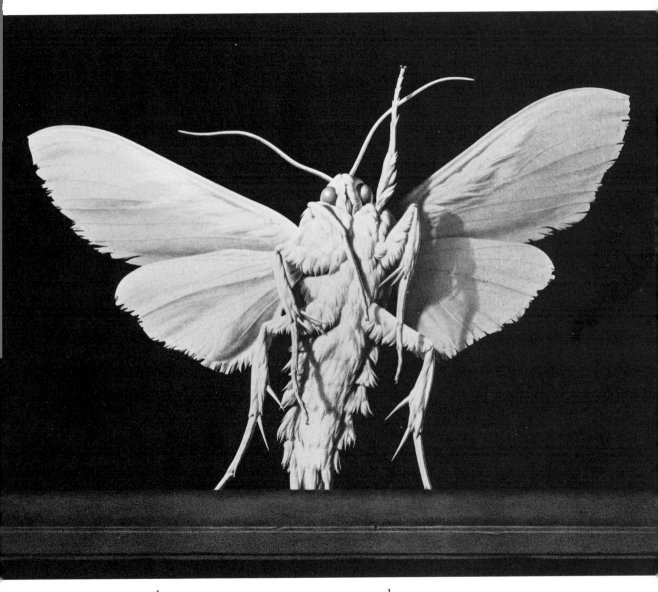

1
MOTH
Watercolour and crayon, 1944/45

1
NACHTFALTER
Aquarell und Buntstift, 1944/45

THE PAINTER PETER BIRKHÄUSER

"I experience a power within myself which is not the same as my conscious ego. It has forced me to adopt a path quite foreign to my conscious attitude, a path which totally contradicted my will and everything I considered important. Before I was able to obey this power, I first needed to be crushed and almost destroyed. I often felt it was a pity this process had taken so long, but now, looking back over thousands of dreams and the sacrifices of a long, hard development, I can see how valuable the experience has been."
*(Peter Birkhäuser in conversation with Dean Frantz, ca. 1975.)**

Eva Wertenschlag
Kaspar Birkhäuser

Peter Birkhäuser was born on 7 June 1911 in Basel. His father was an oculist. Birkhäuser's childhood was overshadowed by the early death of his mother, but even as a child he had decided he wanted to be a painter. A medieval picture of a knight in armour in the Basel art gallery had fascinated him so much that he thought to himself: "I must become a painter. I want to learn to paint knights like that."

His urge to paint caused Birkhäuser to leave grammar school early and study at art college under the well-known Basel artist Niklaus Stoecklin. There followed two decades of artistic activity which found general sympathy and approval. Birkhäuser reproduced what he saw in nature and human beings with as much technical and aesthetic skill as he could apply. He tried to follow the example of the old masters, rejecting contemporary modern art because it seemed to him to be empty and have a merely destructive function.

He was extremely versatile in the production of paintings and drawings, with cartoons for the satirical magazine 'Nebelspalter', posters, ex libris plates, stamps, shop signs, labels, travel sketches of houses and landscapes, still-life paintings, urban

scenes, and, with increasing enthusiasm, portraits. His portraits were expressive, like his original posters, a quality which made his work familiar and sought-after. At the beginning of the thirties he met his future wife Sibylle Oeri. They married in 1939.

One evening, while he was working in his studio, a moth fluttered and settled against the outside of the windowpane. Birkhäuser turned this event into a painting (see plate 1) in which the moth appears to be of monstrous proportions with a wing-span of several yards. He interpreted this picture years later as a representation of his own state of mind. The moth, an image of the soul, was prevented by the glass from reaching the light, that is to say his consciousness. He had grown up in a rationalistic and agnostic environment, and his instincts were all against the unconscious of the religious.

The problems the moth painting had involuntarily charted developed into a real crisis in Birkhäuser's life when he was about thirty. His artistic work refused to go smoothly. His attachment to tradition was a source of dissatisfaction to him. Constant and one-sided imitation of external forms made him less and less happy. He lost his old enthusiasm for his work. Pictures required more and more effort. They stood around for long periods half-finished, and completing them only brought feelings of disgust. Painting produced a sense of impotence, and he suffered more and more frequent fits of depression.

It was in this state of perplexity that Birkhäuser and his wife came upon the ideas of C.G. Jung, and, impressed, began to note and analyse their dreams. Soon the dreams became recognizable as landmarks, unmistakably criticising Birkhäuser's

tradition-bound style. One example among many was a dream in which Birkhäuser was at work on a painstakingly detailed study from nature when he noticed that his hand in the act of drawing was turning into a rigid horn.

The unconscious, however, also drew Birkhäuser's attention to new potentialities. Once he had this dream: "I was in bed and had a woman beside me I didn't know. She told me to get up and go to the blue light. At first I was reluctant, too lazy. Then she ordered me again, and I did ..." The creative side of Birkhäuser's personality demanded a quest for a new spiritual value.

The artist and his wife both entered a Jungian analysis at this time. The analysis turned out to be for life. In the course of 35 years Birkhäuser collected and worked on more than 3400 of his own dreams.

One key dream from 1942 made it clear that Birkhäuser should choose his own individual direction: in the dream the painter and his wife were being swept along in a vast stream of people all going the same way. All at once two giants in front of them turned to the left and strode off against the current of people pushing forwards. Birkhäuser and his wife followed them, but could hardly keep up with them for the tides of people continually dragging them the other way. The exertion of fighting their way through was finally rewarded when they came to a great table richly laden with good things.

Spiritual regeneration provoked a long period of questing in Birkhäuser's paintings. On the one hand he still continued for many years to paint in his old style, but at the same time, dissatisfied with that, he was attempting to placate the promp-

11

tings of the unconscious with compromises. During and towards the end of the forties he produced several paintings which could be called half realism and half fantasy. One of these shows immense flowers rising out of clouds and high above in the sky, at a great distance, a rowing-boat seen from below. In other words it still included objects which exist in the external world and had been studied minutely by the artist. The new factor was that these were now being combined in a more irrational composition.

So there was still a dissonance between what Birkhäuser was doing and what his unconscious wanted him to do. A dream he had at the time illustrates this: On the way home Birkhäuser met a woman who led him into a vault with walls hung with copper baking moulds. He noticed particularly some big fish. Feeling pleased, he went on and came into a narrow passageway. In a dark corner stood an old woman threatening him with a knife. Fog began to swirl around him, thickening with every step he took nearer the woman, and in addition his eyes grew weaker. In terror he felt his way past her and successfully reached his front door. Now he could see clearly again, opened his letter box, and a vast amount of letters poured out.

In the dream the moulds represent Birkhäuser's chance of recasting spiritual elements through art. The positive female figure – called in psychology the anima – shows him how to realise his chance. But on the other hand he is threatened by a destructive side of himself which tries to chain him to a dead tradition and sterile art. Should he succeed in bypassing the witch and avoiding her benighting influence, he wins through to his 'correspondence', i.e. to a treasure of inspiration. For

12

Birkhäuser, overcoming dead tradition meant: "I had to give up all my old ideals one after another, which was very painful." Just how hard this struggle with himself must have been is suggested by the fact that it took the artist twelve years to make the great break and paint a picture entirely according to his own imagination, with no model from the real world.

In 1953 Birkhäuser painted 'The World's Wound'. "In rage and despair I smudged the picture on to the canvas with no faith that anything reasonable would come out." The painter often stressed that this picture of a split man was in no sense a product of his conscious will. He had simply bowed to compulsion after four years of being haunted by that face in his dreams.

This picture was Birkhäuser's breakthrough to so-called pictures of the imagination. In other words he began to put forms and images from the unconscious on canvas without any kind of model from external reality and free from slavish conscious control. The painter himself said about his imaginative pictures:

"I can't always bring it out at the first attempt, because it's difficult to keep in touch with the intuition that is guiding me. Then sometimes I find the right way of expression at once, or to put it more accurately: it reveals itself suddenly. Usually it is groping in the dark, fetching it out. From time to time I get myself on the wrong track without noticing it. Then a very critical dream may emerge, and I realise that I shall have to start all over again. It can drive one to despair. Then I try again and to my surprise the painting assumes a totally unexpected form. Usually the unconscious presents me with a new

content, a form or an idea, it seems ot ambush me. But then I have to find a way of putting it on canvas. To have the right attitude is a very serious problem; I'm glad I had the opportunity of discussing this with Jung."

Jung had said: "The dream provides the stimulus, but it is only a sketch, a cartoon, *you* have to develop it and give it form."

To which Birkhäuser had replied: "But I'm always afraid I will distort the original notion too much. In transferring such a delicate insubstantial thing to canvas with thick oil colours it often tends to change. Additional ideas which were not in the original impulse begin to obtrude."

Jung answered: "That doesn't matter, that too is part of the unconscious impulse."*

The process described in this quotation took time to bring about. He had to make a fresh effort for each new picture. Looking at the paintings of his last 25 years it becomes clear how he increasingly succeeded in fulfilling the promptings of the unconscious. His images resemble less and less the shapes of the external world, and lose their material quality. One of the techniques which produce this effect is that light and shade disappear and the painted forms seem to be light themselves. But the thing which is of most general interest in the fantasy pictures is that they reflect not only the artist's own personal psychological situation, but that they reveal images from the collective unconscious which concern our whole age and culture. Paintings like 'The World's Wound', 'Imprisoned Creative Power', 'The Outcast', or 'Divine Fire' have something to say to us all.

14

From the moment Birkhäuser introduced the first of these fantasies to the public, he met with blank incomprehension. As his paintings introduced genuinely new subject matter, the art world rejected them. Many of Birkhäuser's own friends were alienated, so that the painter became increasingly isolated. During this time he was unable to support himself from his painting and was forced to live from advertising work. Only gradually did a new group of people appear who appreciated and bought his paintings; many of them were younger people, often from America. In this period of obscurity and lack of public success three personal relationships stood him in particularly good stead. His wife was unshakably loyal and a constructive critic. He also enjoyed decisive support from his analyst and friend Marie-Louise von Franz. In addition, another painter and his closest friend, Erhard Jacoby, was making similar attempts to represent images from the unconscious.

In 1969 he lost his friend Jacoby, and in 1971 his wife. That year saw the beginning of a serious lung complaint, but increasing physical handicaps in the last five years of his life were accompanied by striking progress in his spiritual development and artistic productivity. He devoted himself exclusively to painting and the task set by images from the unconscious. The full and detailed diary of dreams gave Birkhäuser a perspective over 35 years of his life. Now he could discern a sense of purpose in the way the unconscious had steered him along a path he had been reluctant to go. This prompted Birkhäuser's comment, not the product of any theory, but of personal experience:

"This mysterious power has its own will and ends. It knows

things that no human being could know. So I'm sure it would not be wrong to give it the name of God. It is after all greater than every human faculty. It is what we impute to God, to know the future, or to know what an individual should do in the decades ahead."*

Translated by Michael Mitchell

Bibliography

Marie-Louise von Franz: Peter Birkhäuser: A Modern Artist who Strikes a New Path. In: Spring – Contributions to Jungian Thought. New York 1964.
Dean L. Frantz: Meaning for Modern Man in the Paintings of Peter Birkhäuser. Diploma thesis, Jung-Institute, Zürich 1977.

N.B. Quotations furnished with an asterisk are adapted from interviews given by Birkhäuser to Dean Frantz and included in his diploma thesis 'Meaning for Modern Man in the Paintings of Peter Birkhäuser', Jung-Institute, Zürich 1977.

DER MALER PETER BIRKHÄUSER

«Ich erlebe eine Kraft in mir, die nicht meinem Ich entspricht. Sie hat mich gezwungen, einen meinem Bewusstsein gänzlich fremden Weg einzuschlagen. Dieser Weg hat meinem Willen und allem, was mir wert gewesen ist, völlig widersprochen. Bevor ich jener Kraft gehorchen konnte, musste ich zuerst ganz gebrochen und fast zerstört werden. Oft dachte ich, es sei schade, dass dieser Prozess so viel Zeit beansprucht hat. Aber jetzt, da ich auf Tausende von Träumen, auf diese lange Entwicklung mit harten Zeiten und Opfern zurückblicke, jetzt sehe ich, wie kostbar diese Erfahrung ist.»
*(Äusserung Peter Birkhäusers Dean Frantz gegenüber, etwa 1975.)**

Eva Wertenschlag
Kaspar Birkhäuser

Peter Birkhäuser wurde am 7. Juni 1911 in Basel geboren. Sein Vater war Augenarzt. Birkhäusers Kindheit wurde durch den frühen Tod der Mutter überschattet. Schon als Kind stand für ihn fest, dass er später Maler werden wollte. Im Kunstmuseum Basel begeisterte ihn nämlich die mittelalterliche Darstellung eines Ritters derartig, dass er dachte: «Ich muss Maler werden. Ich will lernen, solche Ritter zu malen.»

Sein Drang zum Malen veranlasste Birkhäuser, das Gymnasium vorzeitig zu verlassen und sich an der Kunstgewerbeschule und bei dem bekannten Basler Maler Niklaus Stoecklin auszubilden. Es folgte in den nächsten zwei Jahrzehnten eine berufliche Tätigkeit, die allseits Anerkennung fand. Birkhäuser stellte mit Pinsel und Stift möglichst schön, ästhetisch und technisch perfekt dar, was er in der Natur und bei den Menschen sah. Seine Vorbilder waren die alten Meister. Die moderne Kunst seiner Zeit lehnte er ab, weil sie ihm leer und als blosse Destruktion des traditionellen Weltbilds vorkam.

Als Kunstmaler und Graphiker betätigte er sich äusserst vielseitig. Er zeichnete für die satirische Zeitschrift ‹Nebelspalter›, malte Plakate, entwarf Exlibris, Briefmarken, Fassadenschrif-

ten, Etiketten, zeichnete auf Reisen Häuser und Landschaften, malte Stilleben, Blumen, Stadtszenerien und mit zunehmender Liebe Porträts. Seine Porträts hatten durch ihre Beseeltheit eine besondere Qualität und machten ihn ebenso wie seine originellen Plakate beliebt und bekannt. Zu Beginn der dreissiger Jahre lernte er seine Lebensgefährtin, Sibylle Oeri, kennen, die er 1939 heiratete.

Als er eines Abends in seinem Atelier arbeitete, setzte sich von aussen ein Nachtfalter an die Fensterscheibe. Den Anblick dieses Tiers setzte Birkhäuser in ein Gemälde um, das den Falter in unheimlicher Grösse mit meterbreiter Flügelspannweite zeigt (vgl. Tafel 1). Im Alter interpretierte er dieses Bild als eine symbolische Darstellung seines damaligen geistigen Zustandes: Der Falter als Bild für das Seelische wurde durch die Fensterscheibe daran gehindert, zu ihm ans Licht, das heisst in sein Bewusstsein, zu kommen.

Und tatsächlich war Birkhäuser damals gänzlich abgespalten vom Unbewussten. Aufgewachsen in einem eher aufklärerisch-rationalistischen Elternhaus, hatte er eine deutlich negative Einstellung allem Seelischen und Religiösen gegenüber.

Die im Falterbild ungewollt dargestellte Problematik entwikkelte sich für Birkhäuser, als er etwa dreissig Jahre alt war, zu einer eigentlichen Lebenskrise. Bei seiner künstlerischen Arbeit tauchten Schwierigkeiten auf. Seine Befangenheit in der Tradition wurde für ihn unbefriedigend. Die ständige einseitige Darstellung von Äusserem machte den Maler mehr und mehr unglücklich. Er verlor die alte Begeisterung an seinem Schaffen. Bilder kamen nur noch mit Mühe zustande. Lange standen sie unfertig umher. Und nur mit Gefühlen der Unlust vollendete

Birkhäuser sie schliesslich. Er fühlte sich oft wie gelähmt beim Malen. Immer häufiger verfiel er in Depressionen.

In ihrer damaligen Ratlosigkeit stiessen Birkhäuser und seine Frau auf die Gedankenwelt C.G. Jungs, und beeindruckt davon begannen sie, ihre Träume zu beobachten und zu analysieren. Und die Träume erwiesen sich bald als konkrete Orientierungshilfen. Unmissverständlich kritisierten sie etwa Birkhäusers traditionelle Malerei. Ein Beispiel von vielen ähnlichen ist das folgende: Im Traum war Birkhäuser mit einer sorgfältigen Naturstudie beschäftigt, als er mit Schrecken feststellte, wie seine zeichnende Hand zu unbewegbarem Horn erstarrte.

Vom Unbewussten her wurde Birkhäuser aber auch auf neue Möglichkeiten seiner schöpferischen Tätigkeit aufmerksam gemacht. Damals träumte es ihm: «Ich lag im Bett und hatte eine unbekannte Frau neben mir. Sie hiess mich aufstehen und zum blauen Licht gehen. Erst wollte ich nicht, aus Bequemlichkeit. Da befahl sie es mir nochmals, worauf ich ging ...» – Birkhäusers schöpferische Seite verlangte von ihm eine Suchwanderung nach einem neuen geistigen Wert.

Der Künstler und seine Frau begannen in jenen Jahren beide eine Jungsche Analyse. Es sollten Lebensanalysen werden, die bis zu beider Tod dauerten. Birkhäuser sammelte und verarbeitete während 35 Jahren über 3400 eigene Träume.

Ein Schlüsseltraum von 1942 machte deutlich, dass Birkhäuser fortan einen ganz eigenen Weg einzuschlagen hatte: Der Maler liess sich im Traum mit seiner Frau in einem gigantischen Menschenstrom in eine gewisse Richtung treiben. Plötzlich wichen vor ihnen zwei Riesen nach links ab und schritten gegen den Menschenstrom voran. Birkhäuser und seine Frau

schlossen sich ihnen an, konnten ihnen aber kaum folgen, weil sie von den ihnen entgegenströmenden Menschen immer wieder weggerissen wurden. Nach langem, äusserst anstrengendem Vorwärtskämpfen erreichten sie eine grosse, reichgedeckte Tafel. An dieser wurden sie zum Lohn für ihre Mühen reich bewirtet.

Sein geistiger Neubeginn löste in Birkhäusers malerischem Schaffen eine lange Periode des Suchens aus. Einesteils malte er noch viele Jahre in seinem alten Stil weiter und, unbefriedigt davon, versuchte er andernteils, die Stimme des Unbewussten mit Kompromissmalerei zu beruhigen. In der Mitte und gegen das Ende der vierziger Jahre schuf er einige Bilder, die man halb realistisch, halb phantastisch nennen könnte. Eines jener Bilder etwa zeigt riesige, aus Wolken aufsteigende Blumen und hoch oben am Himmel, in grosser Entfernung, ein von unten gesehenes Ruderboot. Es waren darauf also weiterhin Dinge zu sehen, die in der äusseren Welt existierten und vom Maler genau beobachtet und studiert worden waren. Neu war nur, dass sie zu einer Art von irrationaler Komposition verwertet worden waren.

Es blieb folglich weiterhin ein Zwiespalt bestehen zwischen Birkhäusers künstlerischem Schaffen und dem, was das Unbewusste von ihm verlangte. Ein damaliger Traum weist auf diesen Zwiespalt hin: Auf dem Weg nach Hause begegnete Birkhäuser einer Frau, die ihn in ein Kellergewölbe führte, dessen Wände reich mit kupfernen Backformen behängt waren. Grosse Fische fielen ihm darunter auf. Beglückt setzte er seinen Weg fort und gelangte in eine enge Gasse. Dort stand in einer dunklen Mauerecke eine Alte mit einem Dolch, die nach

seinem Leben trachtete. Nebel begann sich zu bilden und wurde rasch dichter, je näher Birkhäuser, der zusätzlich von einer Augenschwäche befallen wurde, der Alten kam. Angstvoll tastete er sich an ihr vorbei und erreichte glücklich seine Haustür. Er sah jetzt wieder klar, öffnete seinen Briefkasten, und eine Unmenge von Post quoll ihm entgegen.

In diesem Traum verbildlichen die Kupferformen Birkhäusers Möglichkeit, seelische Inhalte künstlerisch neu zu fassen. Die positive Frauengestalt – in psychologischer Sprache seine Anima – öffnet ihm den Zugang zu dieser Möglichkeit. Andererseits ist die Bedrohung durch eine destruktive Seite in ihm, die ihn an tote Tradition und Materie binden will, dargestellt. Gelingt es Birkhäuser, der Hexe aus dem Weg zu gehen und ihrer das Bewusstsein benebelnden Wirkung nicht zu verfallen, erhält er Zugang zu seiner ‹Post›, das heisst zu reichen Inspirationen.

Tote Tradition zu überwinden, bedeutete für Birkhäuser: «Ich musste unter grossen Schmerzen Stück für Stück alle meine alten Ideale aufgeben.» Wie zäh und hart der Kampf und Konflikt mit sich selbst gewesen sein mussten, zeigt allein der Umstand, dass es zwölf Jahre dauerte, bis es dem Künstler gelang, den wesentlichen Schritt zu tun und ohne jedes Vorbild aus der äussern Welt ein Bild rein einer inneren Vorstellung folgend zu malen.

1953 schuf Birkhäuser das Gemälde ‹Der Gespaltene›. «Ich schmierte das Bild voller Wut und Verzweiflung auf die Leinwand, ohne Glaube, dass etwas Rechtes dabei herauskommen werde.» Der Maler betonte übrigens, dass die Abbildung des Gespaltenen keineswegs durch seinen Willen zustande gekom-

men sei. Vielmehr sei er dem reinen Zwang gewichen. Vier Jahre habe ihn das Traumbild dieses Gespaltenen nämlich verfolgt.

Mit dem ‹Gespaltenen› war Birkhäuser der Durchbruch zur sogenannten Phantasiemalerei gelungen. Er begann also, unter Verzicht auf Vorbilder aus der äusseren Realität und auf jegliche Lenkung durch das Bewusstsein, Formen und Inhalte aus dem Unbewussten auf die Leinwand zu bannen. Der Maler äusserte sich zur Entstehungsweise seiner Phantasiebilder folgendermassen:

«Oft gelingt es mir nicht, ein Bild beim ersten Versuch hervorzubringen, weil es schwierig ist, den Kontakt zur führenden Intuition aufrechtzuerhalten. Dann wieder finde ich den passenden Ausdruck auf Anhieb – oder besser: er enthüllt sich mir plötzlich. Meist ist es wie ein Tasten im Dunkeln, ein Hervorsuchen. Manchmal gerate ich auf eine falsche Spur, ohne es zu merken. Dann mag ein Traum mit scharfer Kritik auftauchen. Und ich weiss, dass ich von vorne beginnen muss. Verzweifelt und unsicher suche ich nach einem neuen Weg, und zu meiner Überraschung nimmt das Gemälde plötzlich Formen an, über die ich zuvor nichts gewusst habe. – Meist bringt mir das Unbewusste einen neuen Inhalt nahe, eine Gestalt oder eine Idee, ja oft überfällt es mich damit. Dann aber muss ich einen Weg finden, es auf die Leinwand zu bringen. Dazu die richtige Einstellung zu finden, ist ein ernstes Problem. Ich bin froh, dass ich darüber mit Jung sprechen konnte.»

Jung habe ihm gesagt: «Der Traum gibt den Anstoss, ist aber erst eine Ahnung. Und *Sie* müssen sie ans Licht ziehen und ihr Gestalt geben.»

Worauf Birkhäuser erwidert habe: «Ich befürchte beim Malen aber immer, diese Ahnung zu sehr zu verformen. Indem ich eine solch zarte, unstoffliche Sache mit dicker Ölfarbe auf die Leinwand übertrage, neigt sie oft dazu, verändert zu werden. Zusätzliche Ideen, die ursprünglich nicht in diesem Anstoss enthalten waren, beginnen einzufliessen.»

Jung dazu: «Das macht nichts, auch das gehört zum Impuls aus dem Unbewussten.»*

Was in diesem Zitat geschildert worden ist, konnte Birkhäuser aber nur langsam verwirklichen. Er musste sich beim Malen jeden Bildes neu darum bemühen. Wenn man auf die Bilder seiner letzten 25 Schaffensjahre blickt, erkennt man, wie es ihm zunehmend gelungen ist, den Anstössen aus dem Unbewussten zu entsprechen. Das Dargestellte erinnert immer weniger an Formen aus der äusseren Welt und verliert alle Stofflichkeit. Zu dieser neuen Qualität trägt unter anderem folgendes bei: Es gibt nicht mehr Licht und Schatten, sondern die gemalten Gestalten scheinen selbst Licht zu sein.

Was aber Birkhäusers Phantasiemalerei in das allgemeine Interesse rückt, ist, dass durch sie nicht nur die persönliche seelische Situation des Künstlers gespiegelt wird, sondern dass sie Bilder aus dem kollektiven Unbewussten sichtbar macht, dass sie unser aller Kultur und Zeit betrifft. Bilder wie ‹Der Gespaltene›, ‹Das Tier im Berg›, ‹Der Ausgestossene› oder ‹Gottes Feuer› gehen uns alle an.

Sobald Birkhäuser mit seinen ersten Phantasiebildern an die Öffentlichkeit trat, stiess er auf gänzliches Unverständnis. Da seine Gemälde wirklich neue Inhalte zeigen, lehnte die Welt der Kunst sie ab. Viele Freunde Birkhäusers waren befremdet,

so dass der Maler mehr und mehr isoliert wurde. Während Jahren konnte er seinen Lebensunterhalt nicht mehr aus der Malerei bestreiten und war ganz auf Werbegraphik angewiesen. Nur langsam bildete sich ein neuer Kreis von Interessierten, die seine Phantasiebilder verstanden und kauften. Es waren vorwiegend Amerikaner und jüngere Leute. In jener Zeit, in der Birkhäuser mit seiner Kunst in der Öffentlichkeit einen so schweren Stand hatte, halfen ihm drei menschliche Beziehungen in besonderer Weise. Seine Frau hielt ihm unerschütterlich die Treue und war ihm eine konstruktive Kritikerin. Weiteren entscheidenden Rückhalt bot ihm seine Analytikerin und Freundin Marie-Louise von Franz. Erhard Jacoby, sein engster Freund und selber auch Maler, bemühte sich wie er, Inhalte aus dem Unbewussten darzustellen.

1969 verlor er seinen Freund Jacoby, 1971 seine Gattin. Seit damals litt Birkhäuser zunehmend unter einer schweren Lungenkrankheit. Seine letzten fünf Lebensjahre wurden für ihn aber zu einer Zeit besonderer seelischer Entwicklung und künstlerischer Fruchtbarkeit. Er widmete sich ausschliesslich seiner Malerei und der Auseinandersetzung mit dem Unbewussten. Anhand seiner umfangreichen Traumaufzeichnungen blickte Birkhäuser auf seine letzten 35 Lebensjahre zurück. In der Art, wie ihn das Unbewusste in eine von ihm ungewollte Richtung gelenkt hatte, konnte er jetzt Sinn und Folgerichtigkeit feststellen. Daher sagte Peter Birkhäuser nicht aufgrund theoretischer Überlegung, sondern aus eigener Erfahrung:

«Diese unbekannte Kraft hat ihren eigenen Willen und ihre eigene Absicht. Sie weiss Dinge, die kein Mensch wissen kann. Daher ist es gewiss nicht falsch, wenn man sie Gott nennt. Ihr

Wissen steht ja über allen menschlichen Möglichkeiten. Nur eine gottähnliche Kraft kann die Zukunft kennen und wissen, was für mich zu tun in den nächsten Jahrzehnten das Richtige ist.»*

Die mit * versehenen Zitate entstammen der Arbeit ‹Meaning for Modern Man in the Paintings of Peter Birkhäuser›, Diplomarbeit von Dean L. Frantz am Jung-Institut, Zürich 1977.

PLATES
COMMENTARIES

BILDTEIL
KOMMENTARE

Peter Birkhäuser's pictures are pure
products of his unconscious mind.
These commentaries do not
represent any conscious thoughts of the
artist's. They are attempts subsequently
to achieve an understanding of the
paintings and thus to hint at possible
interpretations.
Marie-Louise von Franz

Peter Birkhäuser hat seine Bilder
rein aus dem Unbewussten heraus
geschaffen. Diese Kommentare
entsprechen keinen bewussten
Gedanken des Malers. Sie sind
Versuche, nachträglich etwas von
dieser Malerei zu verstehen und die
Bilder so dem Betrachter
andeutungsweise zu erschliessen.
Marie-Louise von Franz

2
THE WORLD'S WOUND

In a dream this man was desperately
trying to reach P.B. He personifies the
tragic inner split of modern man, who
through reliance on rationality has lost
the spirituality of natural man. We can
no longer overcome this split, but we
can become conscious of it. Then the
creative spirit of the unconscious could
be reintegrated with our consciousness.
The eye on the left is opened in fearful
vision, that on the right remains
sceptical and cool. It was after this
encounter that P.B. felt urged to give
up painting motifs of his own choice
and devote himself to representing the
sufferings of our age as reflected in the
collective unconscious.
Oil, January 1953

2
DER GESPALTENE

In einem Traum versuchte dieser Mann
verzweifelt, P.B. zu erreichen. Er
verkörpert die Tragik des modernen
Menschen, der durch seine rationale
Welteinstellung die Weltsicht des
natürlichen Menschen verdrängt hat.
Wir können diese Spaltung nicht mehr
aufheben, aber ihrer bewusst werden,
so dass sich dann der Geist des
Unbewussten schöpferisch mit dem
Bewusstsein verbinden könnte. Das
linke Auge ist angstvoll sehend
aufgerissen, das rechte blickt sachlich-
skeptisch. Von dieser Begegnung an
fühlte sich P.B. gedrängt, nicht mehr
Motive seiner eigenen Wahl, sondern
des Leidens unserer Zeit, wie es sich im
Unbewussten spiegelt, zu malen.
Öl, Januar 1953

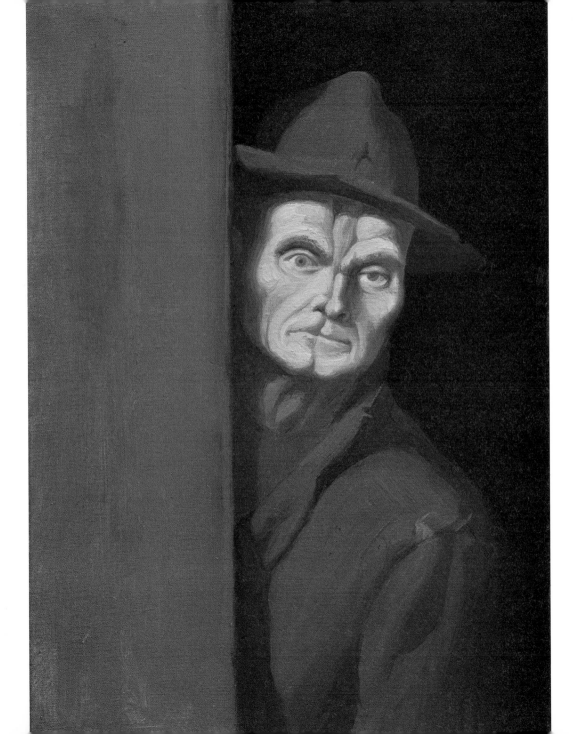

3
THE CAT

The 'old woman' with her evil claws
and her mysterious animal eyes. In
dreams she threatened the artist's life,
but also appeared as the guardian of
undiscovered treasures. She is the
'Great Mother' who can paralyse those
who desire to regress to her, but who
also possesses the age-old secrets of the
instincts and nature. In later dreams
she also appeared as a murderous
praying mantis. Her negative aspect is
a reflection of a negative attitude
towards her. This gives her the
expectant, watchful look, as if
acceptance of her would reveal quite a
different side. Then she could become,
like the Egyptian cat goddess Bastet, a
bringer of joy and vitality.
Oil, between 1949 and 1955

3
DIE KATZE

Die ‹Alte› mit ihren Raubtierklauen
und ihrem geheimnisvollen Tierblick.
Sie trachtet dem Maler nach dem
Leben und ist zugleich die Hüterin
noch zu entdeckender seelischer
Schätze. Sie ist die ‹grosse Mutter›, zu
der sich zurückzusehnen lähmt, und die
doch das uralte Wissen der Natur
besitzt. Später erschien sie in Träumen
auch als mörderische Gottesanbeterin.
Ihre finstere Seite ist eine Spiegelung
einer negativen Bewusstseinseinstellung
zu ihr, daher ihr lauernder,
erwartungsvoller Blick, als ob sie, wenn
sie angenommen würde, eine ganz
andere Seite enthüllen könnte; dann
würde sie wie die ägyptische
Katzengöttin Bastet eine Spenderin der
Lebensfreude.
Öl, zwischen 1949 und 1955

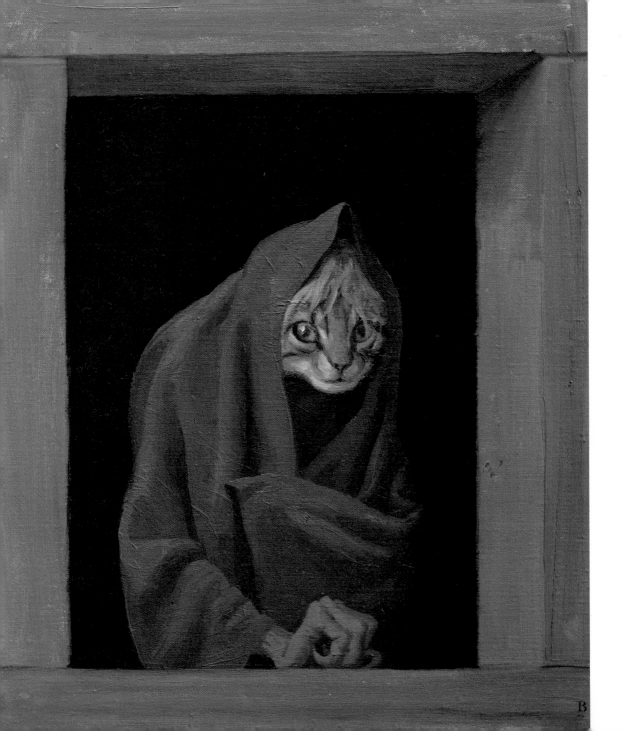

4
DEPRESSION

Every new creation is preceded by an annihilation of the hitherto conscious views. Everything has become stale and meaningless, and the unknown psychic realm reaches out to grasp with tentacles like mist, like liquid or ectoplasm. Depression dissolves the head of the painter, as he sits idly with his back to the easel, suspended in space, with nothing solid beneath his feet. Only by turning round to face the uncanny powers can he discover their secret intentions.
Oil, 1954/55

4
DEPRESSION

Jeder neuen Schöpfung geht eine Vernichtung der bisherigen Bewusstseinswelt voraus; alles ist schal und sinnlos geworden. Die Depression löst dem Maler, der untätig dasitzt, den Kopf auf. Sie ist wie untastbare Nebelschleier. Mit tausend Tentakeln ausgerüstet, saugt sich das Unbekannte der Seelentiefe an ihn an – wie Wasser oder wie Nebel oder Ektoplasma. Erst wenn wir uns umkehren und diesem Unheimlichen ins Gesicht blicken, offenbart es seine geheimen Absichten. Der Maler sitzt im leeren Raum – er hat keinen Boden mehr unter den Füssen.
Öl, 1954/55

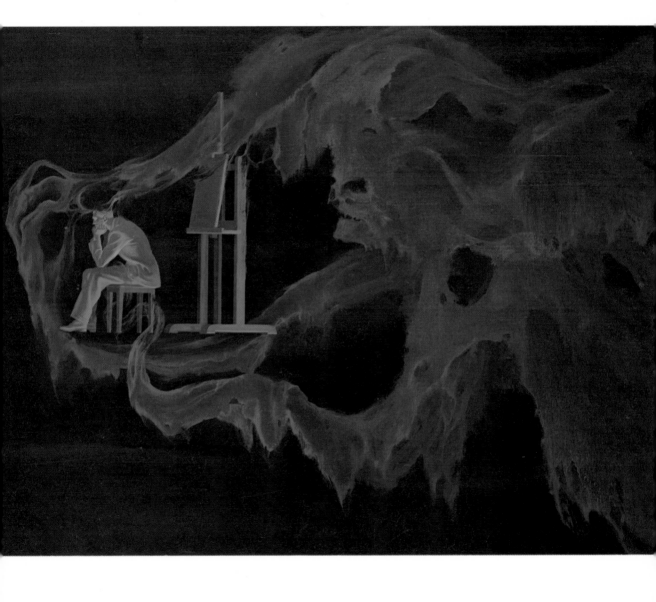

5
COMING UP

The 'ugliest man' (Nietzsche) comes up
from the sewers, hunchbacked and
wretched. His face mirrors the sadness
of a being which has never been loved,
for we have turned away from our
unconscious soul. But in folklore a
hunchback is a bringer of luck; he
carries a lamp, a chance to bring light
into the darkness of our modern world.
Oil, ca. 1954/55

5
DER AUFSTEIGENDE

Bucklig, schmächtig und elend steigt
der ‹hässliche Mensch› (Nietzsche) aus
der Tiefe der Kanalisation. Sein
Ausdruck spiegelt das Elend eines
Menschen wider, der nie Liebe erfuhr,
weil wir uns von unserer Seele
abgewandt haben. Aber ein Buckliger
bringt nach dem Volksglauben Glück –
er trägt ein Licht, die Möglichkeit, die
Dunkelheit unserer verfahrenen Welt
zu erhellen.
Öl, etwa 1954/55

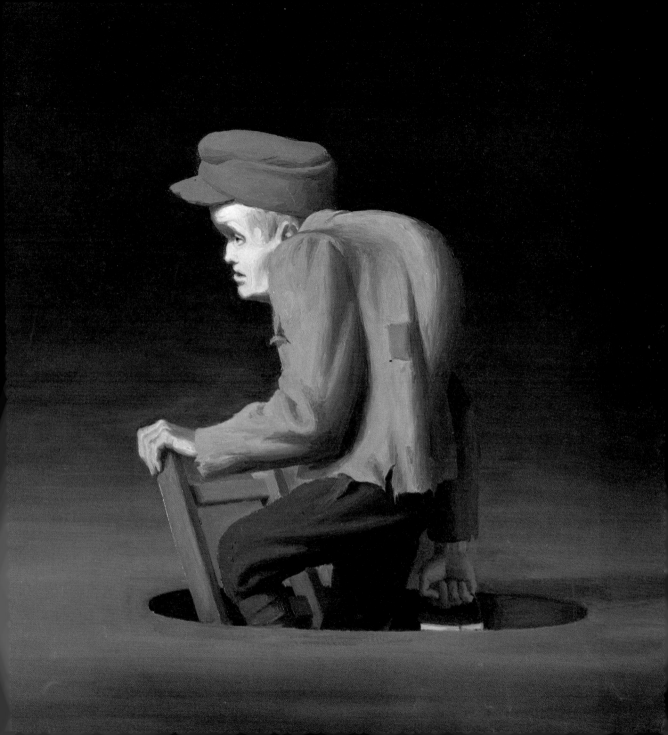

6

THE INWARD GAZE

If we look inwards, the 'other' looks at us too, but with a strange faraway eye. The unconscious begins to unveil its secret play of fantasy: images of seductive beauty and the cruellest abysses of nature. They are framed above by a transparent snake, a symbol of spiritual power. Often P. B. was persecuted in his dreams by a strange 'old woman', an unrecognisable, terrifying enemy. This is the dark side of nature, inertia and death, from which the creative artist has to wrestle free again and again. The figure who sees this vision is colourless – his consciousness is drained of life, and the whole play of colours has gone into the reality of his unconscious, where a frog rises from below, an old symbol of resurrection.

Oil, 1954/55

6

DER EINWÄRTSBLICKENDE

Wenn wir nach innen schauen, blickt die ‹andere Seite› auch zu uns herüber. Das Unbewusste beginnt, sein Phantasiespiel zu enthüllen: Bilder von verlockender Schönheit und die grausamsten Abgründe der Natur. – Oben ist eine durchsichtige Schlange, ein Symbol des Geistes. Oft war P. B. in Träumen von einer ‹Alten›, einem unerkennbaren, furchtbaren Wesen, verfolgt. Es stellt die dunkle Seite der Natur dar, Inertie und Tod, aus der sich der schöpferische Mensch immer wieder herausreissen muss. Der nach innen Schauende ist farblos – kein Leben ist mehr in ihm, und das ganze Farbenspiel hat sich in die Wirklichkeit der Seele verlegt, wo unten ein Frosch, ein Symbol der Auferstehung und Wiedergeburt, aufsteigt.

Öl, 1954/55

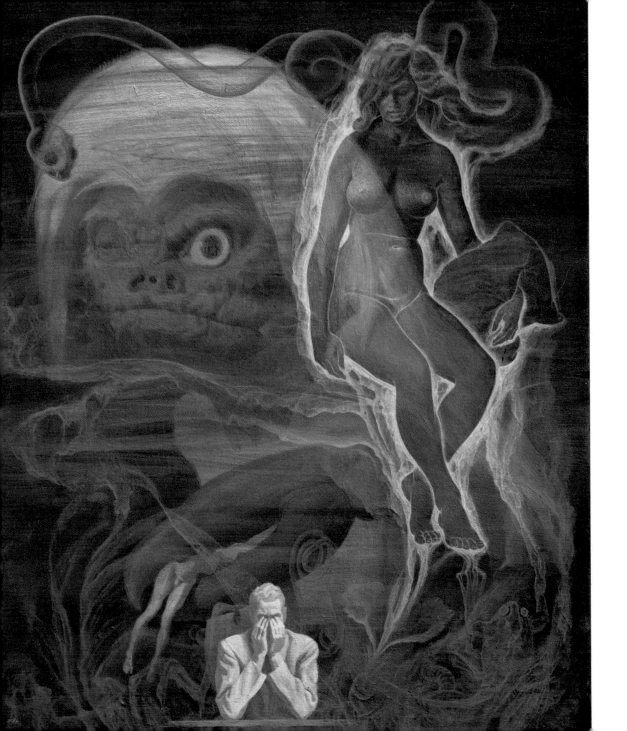

7

THE FOURTH DIMENSION

This picture is based on a vision which
P. B. had on 14 September 1956 and
painted 1956/57. C. G. Jung was
enthusiastic about it and comments on
it in detail in his paper 'Flying Saucers:
A Modern Myth' (C. G. Jung:
Collected Works, vol. 10, para 736 ff.).
The town represents our usual
conscious three-dimensional world, and
through it flows the world of a fourth
dimension, right down into the solid
earth but without touching the town. It
is a sort of cosmic background, also a
'source of living waters'. In it appear
eyes, some clear, some dim, partly
animal and partly human. The vision
portrays the 'other side' of our world, in
which a new God image becomes dimly
visible.
Oil, 1956/57

7

DIE VIERTE DIMENSION

Aufgrund einer Vision vom
14. September 1956 gemalt. Die Stadt
stellt wohl unsere gewöhnliche
dreidimensionale Welt dar. Eine vierte,
mit ihr kommensurable Dimension
durchströmt sie – sogar bis in die
Tiefen der soliden Erde. Sie bildet
einen Welthintergrund, der auch ein
‹Quell lebendigen Wassers› ist. In ihm
erscheinen Augen und drei angedeutete
Gesichter, von einem vierten dominiert.
Sie sind teils tierisch, teils menschlich.
Es ist dies die ‹andere Seite› unserer
Welt, das Unbewusste, in welchem sich
ein Gottesbild andeutet. C. G. Jung war
von diesem Bild begeistert und
bespricht es ausführlich in: ‹Ein neuer
Mythus›, S. 83 ff., Rascher 1958.
Öl, 1956/57

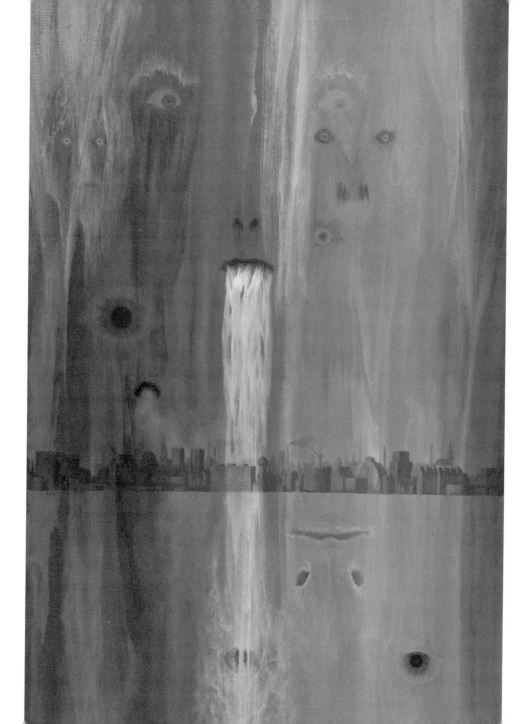

8
IMPRISONED POWER

The 'Archaeus' of Paracelsus, the fiery
creative power of nature in the depths
of the earth or here in a mountain.
Flames shoot out and stones thunder
down – it could erupt and destroy
everything. At the bottom (below right)
a man leaves his car and runs away in
terror. The round golden eye of the
animal is like a seed of light in the
darkness, for the creative powers also
possess the possibility of insight and
consciousness. Like the eye of a bird it
focuses on the far rather than the near.
The animal is a sort of Behemoth, the
dark female side of God, waiting to be
liberated from its prison in the depths
of the earth.
Oil, ca. 1958

8
TIER IM BERG

Der paracelsische ‹Archaeus›, der
feurige Schöpfergeist der Natur im
Bergesinneren, eine Urmacht, die
ausbrechend unsere Welt vernichten
könnte. Flammen schlagen aus dem
Berg, und Steine rollen krachend
herab. Rechts unten ein kleines Auto
und ein flüchtender Mensch. Aber das
runde, goldene Auge des Tiers wirkt
wie ein Lichtkeim in der Finsternis,
Einsicht und Bewusstwerdung
andeutend. Es ist wie ein Vogelauge –
es blickt in die Ferne, nicht auf
Naheliegendes. Das Tier ist wohl eine
Art von Behemoth, die weibliche,
dunkle Seite der Gottheit, welche auf
Befreiung aus der Tiefe wartet.
Öl, etwa 1958

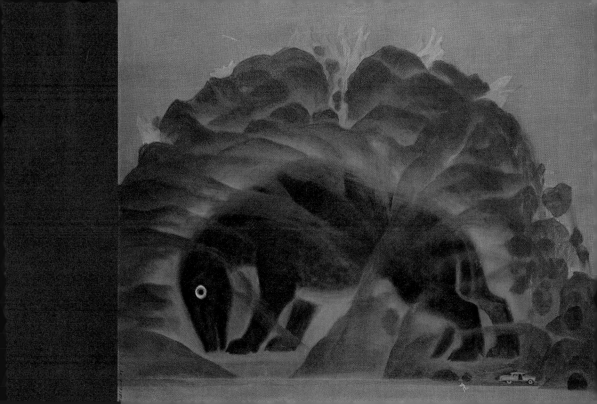

9
FIRE GIVES BIRTH

The sea of flames of the Godhead,
which gives birth to all the colourful
and wondrous forms and shapes of
nature. Out of them man finally also
emerges into the suffering and beauty
of life.
Oil, 1959/60

9
FEUERGEBURT

Das Flammenmeer der Gottheit, das
alle bunten, wundersamen Gestalten
und Formen der Natur gebiert, aus
dem auch der Mensch in das Leiden
und die Schönheit des Lebens
hineingeboren wird.
Öl, 1959/60

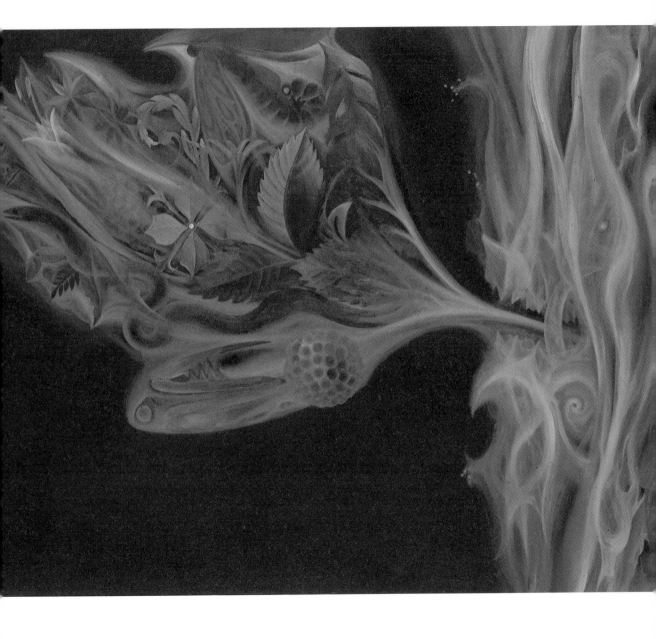

10
THE OUTCAST

From the grey monotony and
functional technology of our
industrialized towns the spirit of the
soul, the creative secret of nature, is
banished. With heavy steps he retreats
towards the left, into the unconscious.
He trails behind him a tail of flames,
which is also a rainbow. The latter
hints that reconciliation with God is
still possible, but the fire could also
destroy all our towns. The face of this
outcast spirit is halved, like the man
with 'The World's Wound'; one half is
green, the colour of life, and one blue
like water or the sky – the Mercurius
duplex of the alchemists, good for the
good and evil for the evil.
Oil, 1960

10
DER AUSGESTOSSENE

In der grauen Eintönigkeit der
Industriestadt und der reinen
Zweckmässigkeit ihrer Technik ist der
Geist der Seele, das schöpferische
Geheimnis des Naturgeistes verbannt.
Mit schweren Schritten zieht er sich
nach links, ins Unbewusste, zurück,
einen Flammenschweif, der zugleich
Regenbogen ist, nach sich ziehend.
Versöhnung mit dem Gott ist noch
möglich, wie der Regenbogen beweist.
Aber dieser Geist kann auch unsere
Städte in einem Flammenmeer
vernichten. Sein Antlitz ist zweigeteilt
wie das des ‹Gespaltenen›, in eine
grüne, naturhafte und eine blaue,
geistige Hälfte. Er ist der Mercurius
duplex der Alchemisten, gut mit den
Guten und böse mit den Bösen.
Öl, 1960

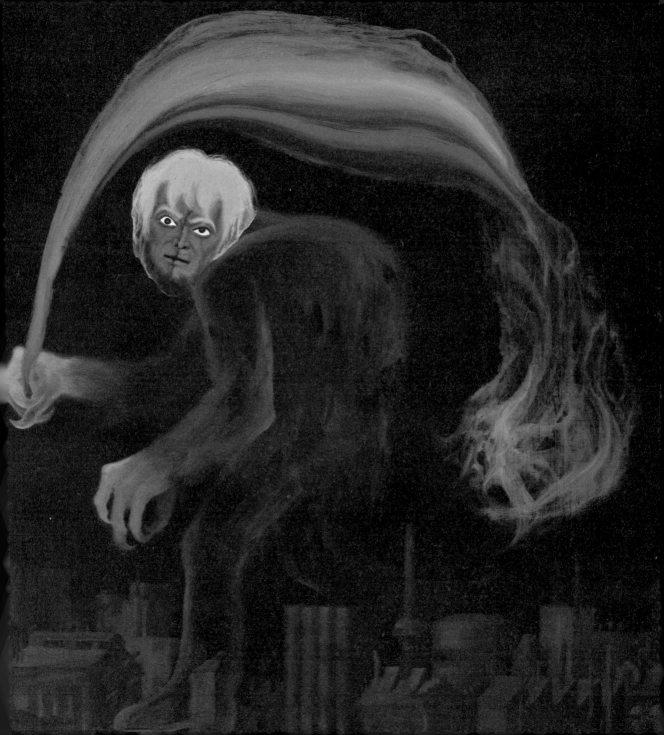

11
PUER

The new spirit of the coming age of
Aquarius, riding on a white beast
(Pegasus) half horse, half boar.
Wherever he stretches his hands, new
life begins to bloom. This is the boy-
god predicted in Revelation as the
child who was snatched up to heaven.
He is the complete man of the future.

You, eternal youth, endless your
agelessness,
Stand in your bloom at the height of
the heavens
Seen, your head unhorned, virginal
The east in your thrall out to black
India
Where the Ganges meets the furthest
border.
(Ovid, Metamorphoses, 4, 18,
translated by Michael Mitchell.)
Oil, April 1960

11
PUER

Der neue Geist des kommenden
Aquariuszeitalters, auf einem weissen
Eberpferd (Pegasus) reitend. Wohin er
seine Hände streckt, erblühen neue
Formen. Er wurde vorausgesagt in der
Offenbarung Johannis als jener Knabe,
der in den Himmel entrückt wurde,
und ist, wie Jung es auslegte, ein Bild
des ‹vollständigen Menschen›.

Unvergänglich ist blühender Jüngling
Deine Jugend, und du wirst der
Schönste gesehen
In dem hohen Olymp. Ohne Hörner
erscheinst du
Wie ein Mädchen gestaltet …
(Ovid, Metamorphosen, 4, 18.)
Öl, April 1960

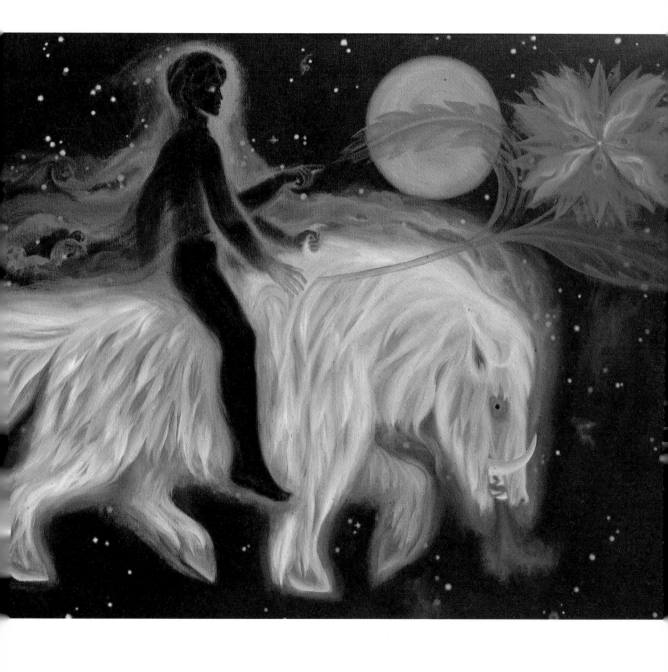

12
THE MAGIC FISH

The future world saviour in his double
form still hidden in the fish in the
depths of the sea. The fish's eye is like a
flower – earth's answer to the light of
the sun. The huge blue eye at the top
left suggests that something in the
cosmic background 'sees' everything.
Within the fish mortal and immortal
man hold each other in a close
embrace.

Two birds, inseparable winged friends,
Cling to one and the same tree.
One of them eats the sweet fruit;
The other looks on, but does not eat.
In such a tree the prostrate spirit,
Bewildered, grieves its impotence,
But honouring the other's power
And majesty, his grief will pass.
(Shvetâshvatara, Uphanishad, IV, 6.)
Oil, 1961

12
ZWILLINGSFISCH

Die Doppelgestalt des kommenden
Weltenheilands, noch im Fisch
verborgen in der Tiefe des Weltmeeres.
Das Auge des Fisches ist wie eine
Blume, eine Antwort der Erde auf das
Sonnenlicht. Ein blaues Riesenauge im
Hintergrund deutet an, dass etwas im
Welthintergrund alles sieht. Die zwei
Gestalten im Fischinnern sind der
sterbliche und der unsterbliche
Mensch.

Zwei schön beflügelte verbundene
Freunde
Umarmen einen und denselben Baum.
Einer von ihnen speist die süsse Beere,
Der andere schaut, nicht essend, nur
herab.
In solchem Baum der Geist,
herabgesunken,
In seiner Ohnmacht grämt sich
wahnbefangen,
Doch wenn er ehrt und schaut des
anderen Allmacht
Und Majestät, dann weicht von ihm
sein Kummer.
(Shvetâshvatara, Uphanischad, IV, 6.)
Öl, 1961

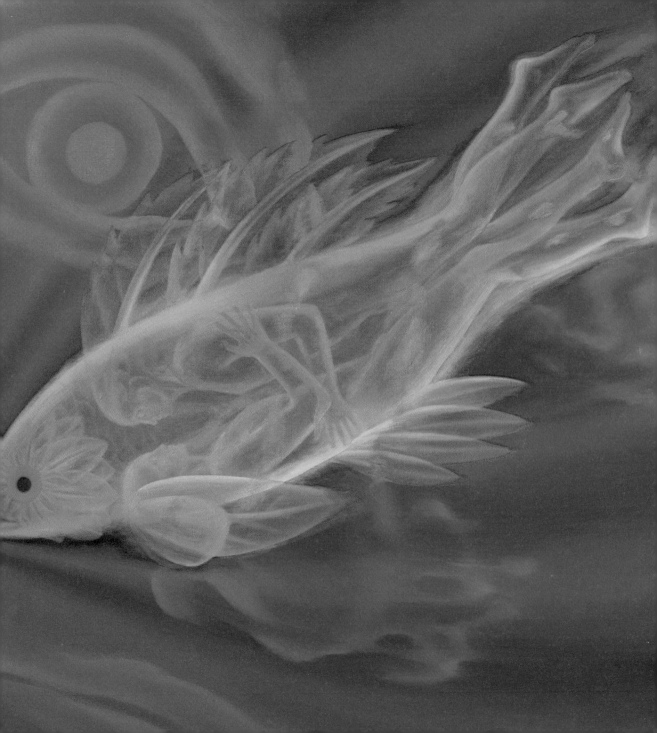

13
A BIRTH

Out of what looks like a mass of
intestines or brainfolds, i.e. out of layers
of the psyche far removed from
consciousness, a transparent man-like
being is born, not onto the earth, but
into free space. This being is
simultaneously an eight-petalled
flower, which has always symbolised
psychic totality, like the 'golden flower'
of the alchemists and Taoists. It is the
image of the resurrection of the inner
man, the self.
Oil, 1961

13
GEBURT AUS DEM JENSEITS

Aus einer Masse, die wie Gedärme oder
Hirnwindungen aussieht – völlig
bewusstseinsferne Bereiche der Seele
andeutend –, wird nach rechts (in
Richtung des Bewusstseins) ein
menschliches Geistwesen geboren. Es ist
der ‹ewige Mensch›, der auch wie eine
achtblättrige Blume erscheint, ein Bild
des Seelenzentrums. Die Alchimisten
nannten ihre vier- oder achtblättrige
Goldblume auch den auferstandenen
inneren Menschen.
Öl, 1961

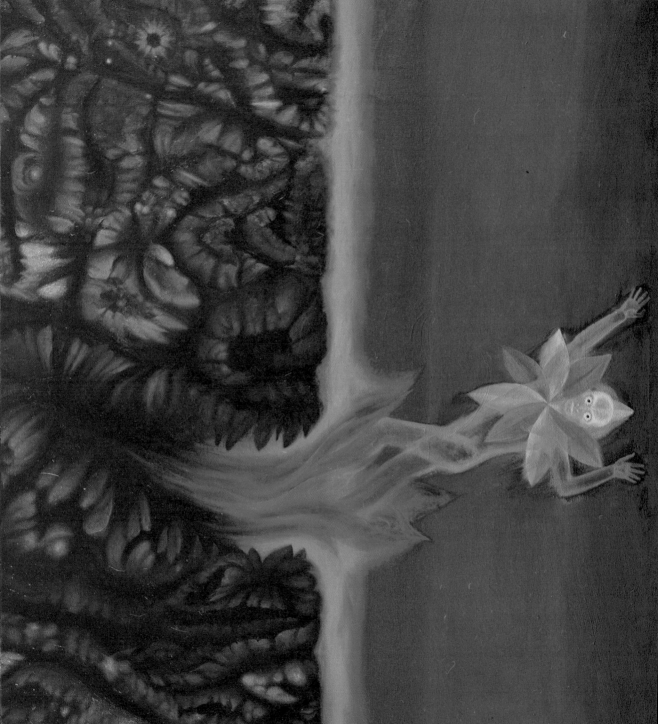

14
THE HIDDEN POWER

This secret ruler reminds one of the
hunchback in 'Coming Up'.
Invulnerable in his heavy armour he
walks towards the left. The creative
principle (dwarves, kabiri are *the*
symbols of creative power) is for man
an unyielding necessity, but the same
figure emanates light, and its head and
shoulders contain the form of an egg –
a germ of new life. The armour is finely
wrought, for creativity seeks perfection
of form.
Oil, May–June 1964

14
DER GEHEIME HERRSCHER

Dieser Herrscher erinnert an den
Buckligen vom Bild ‹Der
Aufsteigende›; aber nun hat sich seine
grössere, göttliche Seite offenbart.
Unbesieglich in seinem harten Panzer,
schreitet er mit schweren Schritten
nach links. Zwerge, Kabiri sind die
grossen Symbolgestalten des
Schöpferischen, der Künstler,
Schmiede und Zauberer. Das
Schöpferische ist ein ‹eherner Zwang›,
aber die Figur strahlt ein Licht aus,
und Kopf und Oberkörper sind wie in
einem Ei enthalten, einem
Keimbehälter neuen Lebens. Der
Panzer ist feinste Arbeit; denn das
Schöpferische sucht, sich in vollendeten
Formen zu manifestieren.
Öl, Mai–Juni 1964

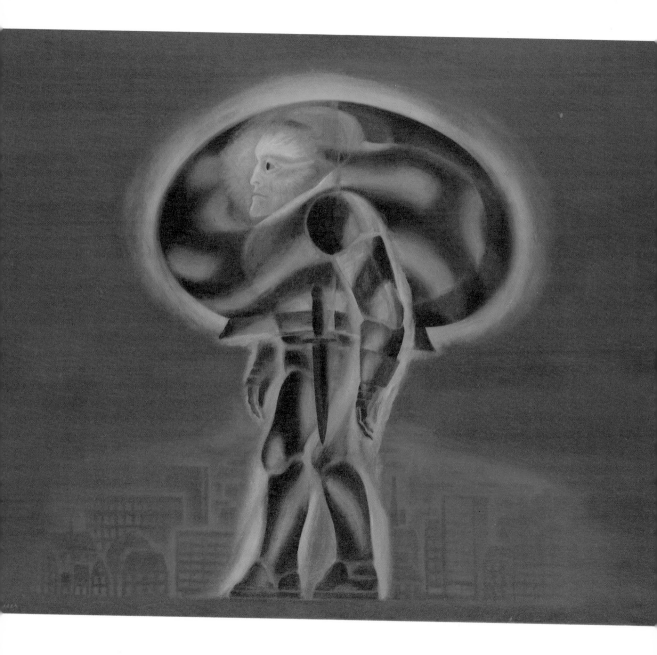

15
MOIRA

The anima (the female soul) of a man is
also his fate, an eternal pattern that is
mirrored in every mother, wife and
lover. "It belongs to him, this perilous
image of Woman; she stands for the
loyalty which in the interests of life he
must sometimes forgo; she is the much-
needed compensation for the risks,
struggles and sacrifices that all end in
disappointment; she is the solace for all
the bitterness of life. And, at the same
time, she is the great illusionist, the
seductress, who draws him into life with
her Maya … Because she is his greatest
danger she demands from man his
greatest, and if he has it in him, she will
receive it." (C. G. Jung: Aion, Collected
Works, vol. 9, II, para 24.) In the
picture she looks towards the left,
towards the unconscious, and her hair
(involuntary thoughts) have the green
colour of vegetation. They form
(according to a dream) a bed in which
'her man' can rest.
Oil, 1965

15
MOIRA

Die Anima (weibliche Seele) des
Mannes ist sein Schicksal; ein
altersloses Bild, das sich in jeder
Mutter, Gattin und Geliebten
widerspiegelt. «Sie gehört zu ihm, sie
ist die Treue, die er, gegebenenfalls um
des Lebens willen, nicht immer haben
darf. Sie ist die unumgängliche
Kompensation für Wagnisse,
Anstrengungen, Opfer, die alle mit
Enttäuschung enden; sie ist die
Trösterin gegenüber all der Bitternis
des Lebens, und zugleich ist sie die
grosse illusionserregende Verführerin
zu eben diesem Leben. Als seine grösste
Gefahr fordert sie Grösstes vom Manne,
und wenn er ein solcher ist, erhält sie es
auch.» (Zit. Jung: Aion.) Die grünen
Haare (= Gedanken) der Anima
bereiten hier (nach einem Traum) ein
Lager für ‹ihren Mann›.
Öl, 1965

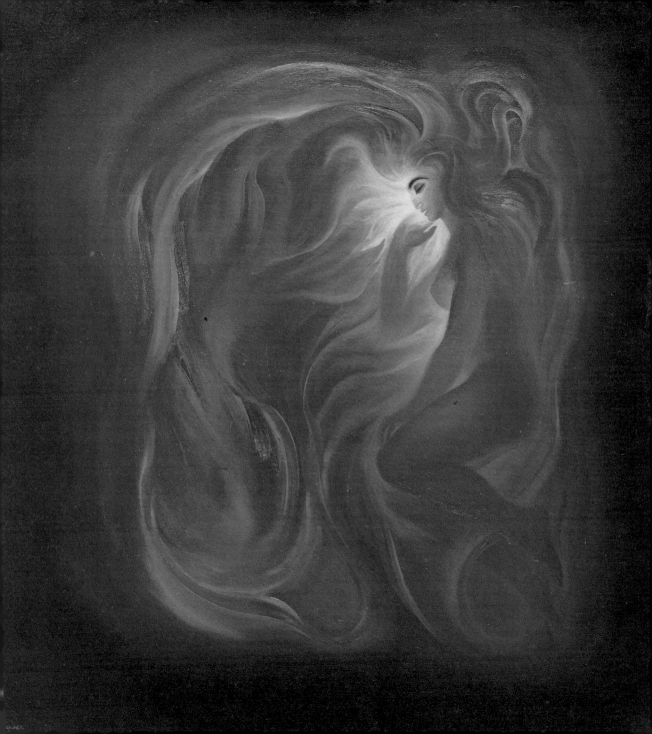

16
AT THE DOOR

The divine creative power comes to the
painter at night out of cosmic space,
wanting to generate and form. But the
artist has locked the door; he is afraid
of his uncanny visitor. The latter,
however, actually brings light and life,
as opposed to the dark, narrow space
where the artist has been living.
Oil, August–September 1965

16
AN DER TÜR

Der Maler nannte das Bild auch
‹Stiermann›. Nachts kommt aus dem
Weltall die göttliche Schöpferkraft zum
Maler und will zeugen und gestalten.
Ängstlich hat der Künstler die Tür
geschlossen; er fürchtet sich vor der
Wucht des Einbrechenden, der aber
eigentlich Leben und Licht besitzt, im
Gegensatz zum engen Raum dessen,
der ohne Kontakt mit dem
Schöpferischen leben will.
Öl, August–September 1965

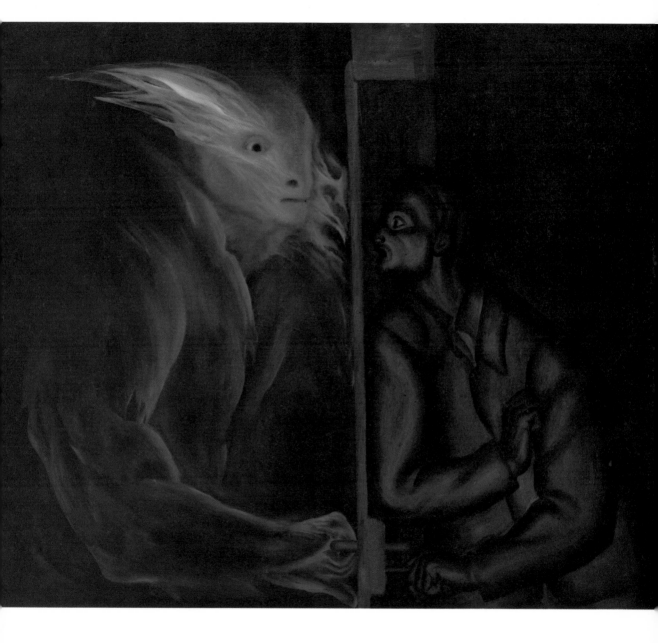

17
WITH CHILD

While a firestorm sweeps over the earth,
the immaterial anima prepares in the
dark depths the birth of the ‹new man›,
the immortal self which transcends
death.
Oil, January 1966

17
SCHWANGERE

Unstofflich, unsichtbar, in der dunklen
Tiefe unter einer vom Feuersturm
heimgesuchten Erde, gebiert die Anima
den ‹neuen Menschen›, welcher den
Tod überdauert.
Öl, Januar 1966

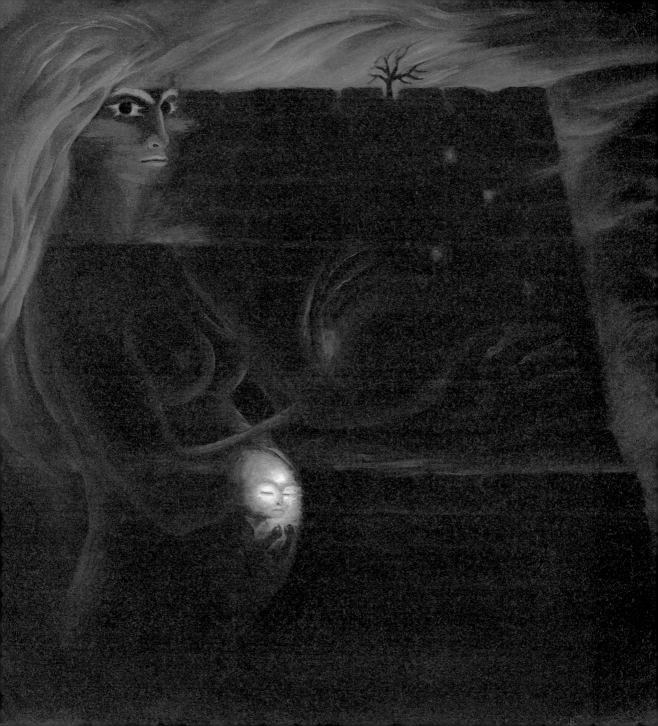

18
ANIMA WITH CROWN OF LIGHT

The anima is a messenger bringing new light. The blue radiance of the spirit shows on her head, whilst she looks inward. This radiance consists of many germs of light, for the self (spiritual totality) is both one and many in one. Gerhard Dorn, the alchemist, points out that by meditating on the image of God, "little by little he (the Adept) will come to see with his mental eye a number of sparks shining day by day and more and more and growing into such a great light that thereafter all things needful to him will be made known" (De Speculativa Philosophia, Theatr. Alchemicum, 1602, vol. I, p. 275).
Oil, September 1966

18
ANIMA MIT LICHTKRONE

Die ‹Herrin Seele› (Spitteler) ist eine Botin; sie überbringt dem Manne neues Licht. Wie eine Krone ist das blaue Licht des Geistes auf ihrem Kopf sichtbar, während sie selbst nach innen blickt. Das Licht ist aus vielen Lichtkeimen zusammengesetzt, denn das Selbst (die seelische Ganzheit) ist eines und vieles zugleich. Wenn der Alchimist über das innere Gottesbild meditiert, sagt Gerhard Dorn, «so wird er mit seinen geistigen Augen wahrnehmen, wie einige Funken mehr und mehr durchschimmern und zu einem grossen Licht anwachsen, dass in der Folgezeit alles bekannt wird, was ihm notwendig ist» (De Speculativa Philosophia, Theatr. Alchemicum, 1602, Vol. I, p. 275).
Öl, September 1966

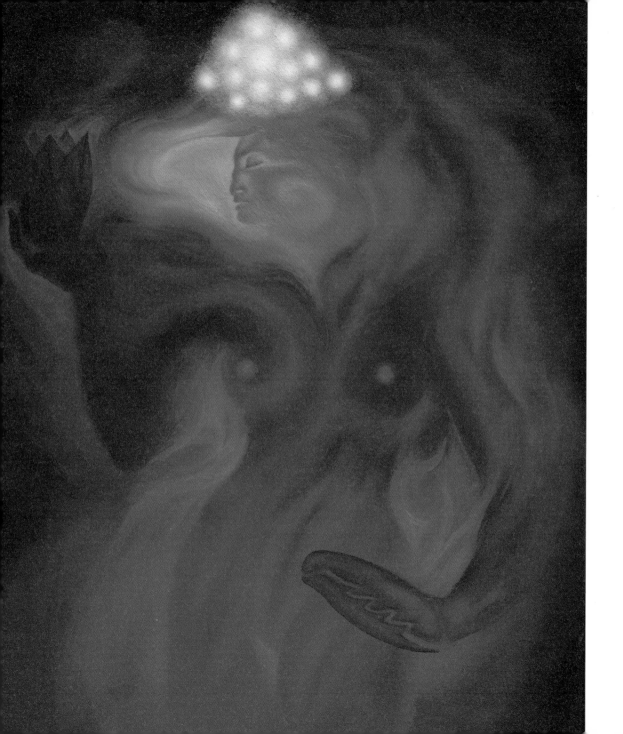

19
THE OBSERVER

Before we know ourselves we are
already 'known'. The self watches us
like a superior observer, as 'private
protection, intimate understanding as
an individual judge, an inexorable
witness' (Apuleius: De Deo Socratis,
chapter 16), allowing no self-deception.
He is both subhuman and superhuman
and sees things far beyond our
conscious mind.
Oil, 1966 (see also lithograph on back
cover)

19
DER BEOBACHTER

Bevor wir irgend etwas von uns selbst
verstehen, sind wir schon ‹erkannt›.
Wie ein übergeordneter Beobachter
wacht das Selbst (das Seelenkern und
Ganzheit darstellt) über uns. Apuleius
(De Deo Socratis, Kap. 16) nennt ihn
‹privaten Beschützer, intimsten
Kenner, individuellen Richter,
unabweisbaren Zeugen›. Er duldet
keine Selbsttäuschungen. Er ist unter-
und übermenschlich und sieht, was
unserem menschlichen Bewusstsein
fernliegt.
Öl, 1966 (vgl. Lithographie auf der
Buchrückseite)

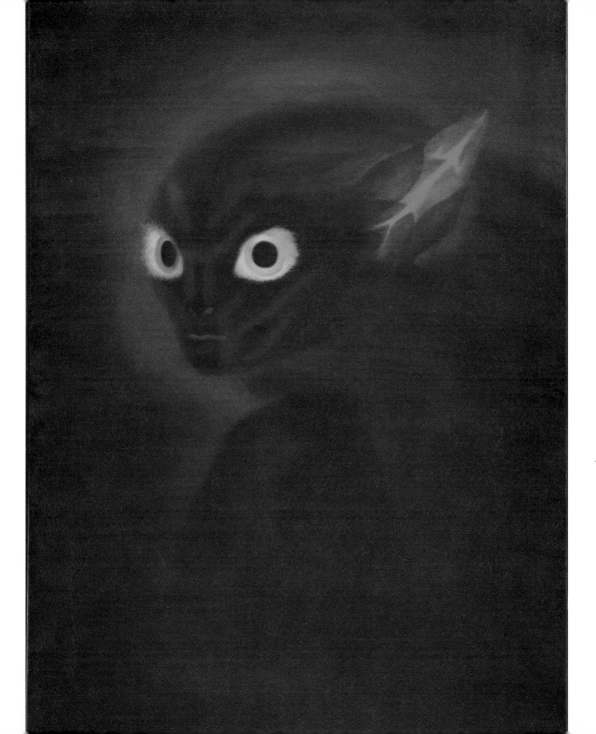

20
BEAR AT THE TREE OF LIGHT

The dark God (Lamentations, 3, 10:
"He lies in wait for me like a bear ...",
verse from Lamentations from New
English Bible) longs for the fruit of the
tree of light, the consciousness of man.
The tree is an image for inner growth
(individuation) during which we
continually find illuminating
realisations. Only if the bear finds no
light does he become dangerous. In this
he resembles the visitor 'At the Door',
so it now becomes clear what this
visitor had wanted.
Crayon, 1968

20
BÄR AM LICHTERBAUM

Der dunkle Gott (Jesaia, Klagelieder,
3, 10: «Er [Gott] hat auf mich gelauert
wie ein Bär, wie ein Löwe im
Verborgenen ...») sehnt sich nach den
Früchten des Lichtbaumes, nach dem
Licht des menschlichen Bewusstseins.
Der Baum ist ein Bild des
Selbstwerdungs- und
Bewusstwerdungsprozesses, im Laufe
dessen dem Menschen immer wieder
‹Lichter aufgehen›. Der Bär gleicht
dem Stiermann (Bild ‹An der Tür›),
und so offenbart sich nun eigentlich,
was jener mit seinem Besuch gewollt
hatte.
Ölkreide, 1968

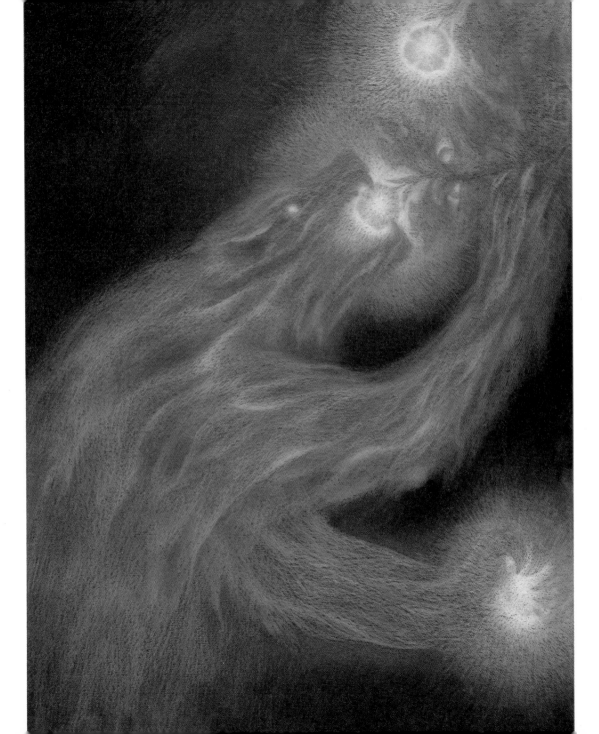

21
SPIRITUS ANIMALIS II

The tortoise is considered in mythology
to be the spirit of the earth. It also
personifies complete introversion. Its
shell was used by the ancient Chinese
for divination, heating it up and
reading the future from the cracks. This
tortoise man – a symbol of the self – is
pointing to the left, towards the
unconscious. He is glowing with an
inner fire, and his knowing eye suggests
secret wisdom.
Crayon, ca. 1968

21
SCHILDKRÖTENMANN

In Jungscher Sprache stellt dieses
Wesen das Selbst, die innere Ganzheit
dar. Die Schildkröte gilt als uralter
Geist der Erde. Sie verkörpert auch
völligste Introversion. Ihr gemusterter
Panzer wurde in China zu
Orakelzwecken verwendet, indem man
ihn erhitzte und dann aus den
Bruchlinien die Zukunft herauslas. Der
Schildkrötenmann des Bildes weist
nach links, das heisst auf die Bedeutung
des Unbewussten. Er ist von Feuer
durchglüht, und sein kluges Auge weist
auf geheimes Wissen hin.
Ölkreide, etwa 1968

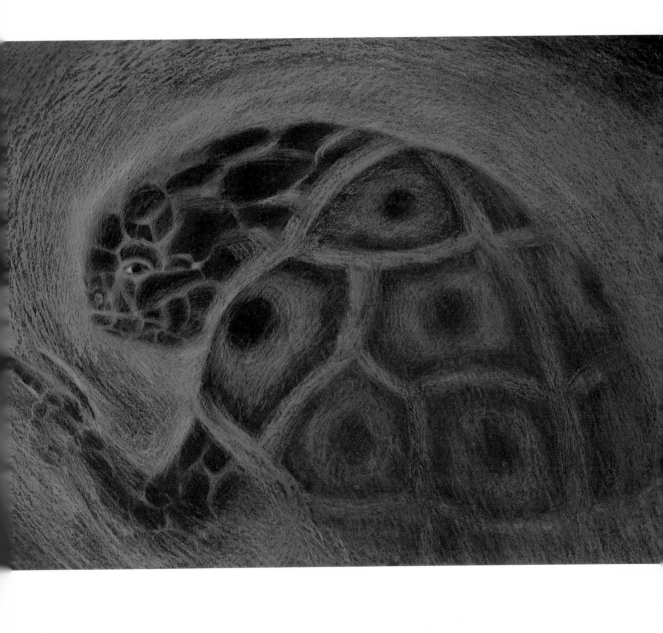

22
WINDOW ON ETERNITY

According to Gerhard Dorn, whoever opens his soul to the 'influx of the divine' receives the revivifying experience of a higher world order. A 'spiracle of eternal life' or 'window on eternity' opens up and frees the soul of too narrow a view of reality (Jung: Mysterium Conjunctionis, Collected Works, vol. 14, para 670). The artist has himself become part of this spirit, for it uses the hand of mortal man in order to reveal its mysterious cosmic constellations.
Crayon, August 1970

22
DAS FENSTER ZUR EWIGKEIT

Wer sich nach Ansicht des Alchimisten Gerhard Dorn dem ‹göttlichen Einfliessen› des Geistes in die Seele öffnet, empfängt die Erkenntnis einer höheren Weltordnung. Es öffnet sich ihm ein ‹Luftloch des ewigen Lebens› oder ein ‹Fenster zur Ewigkeit›, wodurch die Seele belebt wird. Es ist ein Ausblick, der uns ‹von dem erstickenden Zugriff eines einseitigen Weltbildes erlöst› (Jung, Mysterium Conjunctionis II, para 418). Der Maler ist hier selber ein Stück dieses kosmischen Geistes, indem letzterer sich der Hand des sterblichen Menschen bedient, um seine geheimen Ordnungen abzubilden.
Ölkreide, August 1970

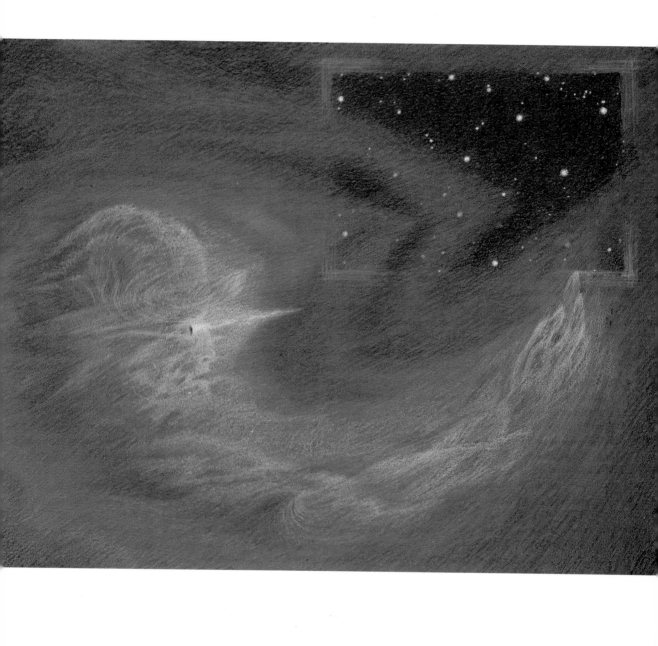

23
THE WOMAN WITH THE CUP

The 'white lady' is popularly
considered a harbinger of death (thus
the darkened eyes) and she brings the
cup of suffering and transformation.
Shortly after the painting of this
picture, P. B.'s wife died suddenly. The
delicate vessel is reminiscent of the
Grail which provides truth and
spiritual nourishment. The whole
ghostly figure seems to be outside the
colourful realm of life.
Oil, March 1971

23
DIE WEISSE FRAU

Die ‹Weisse Frau› ist im Volksglauben
eine Todeskünderin (daher die
lichtlosen Augen), und sie bringt den
Kelch der leidvollen Verwandlung.
Kurz nach dem Malen dieses Bildes
verlor P. B. seine Gattin durch den Tod.
Das zarte Gefäss, das die Frau hält,
erinnert an das Gralsgefäss, welches
Wahrheit und geistige Nahrung
spendet. Die ganze Gestalt ist dem
Farbenspiel des Lebens entrückt und
von einem geisterhaften blauen Licht
umspielt.
Öl, März 1971

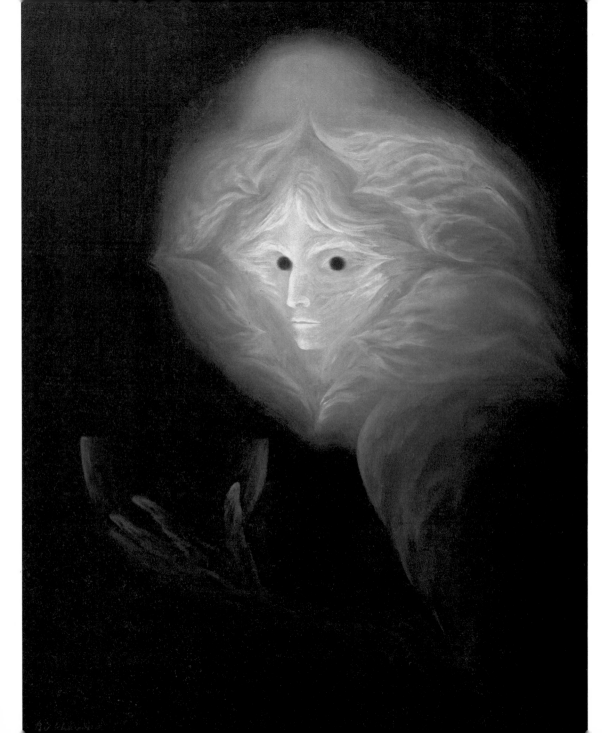

24
24 MARCH 1971

This is the date of the unexpected and
sudden death of Sibylle Birkhäuser.
Although the whole framework of life
(the house) has been shattered by the
lightning, a suggestion lies beyond that
what appears to be senseless and
accidental is in fact the work of a
cosmic force with human
characteristics, in other words that
meaning could after all be found in
such a tragedy.
Oil, 1971

24
DER 24. MÄRZ 1971

Das ist das Datum des unerwarteten,
plötzlichen Todes von Sibylle
Birkhäuser. Obwohl der ganze
Lebensrahmen – das Haus – von einem
Blitz zersprengt wurde, tauchte
dahinter eine Ahnung auf, dass dieses
sinnlos-zufällige Geschehen die Tat
eines menschenähnlichen kosmischen
Geistwesens sein, das heisst, dass doch
auch ein Sinn in solchem Unglück
gefunden werden könnte.
Öl, 1971

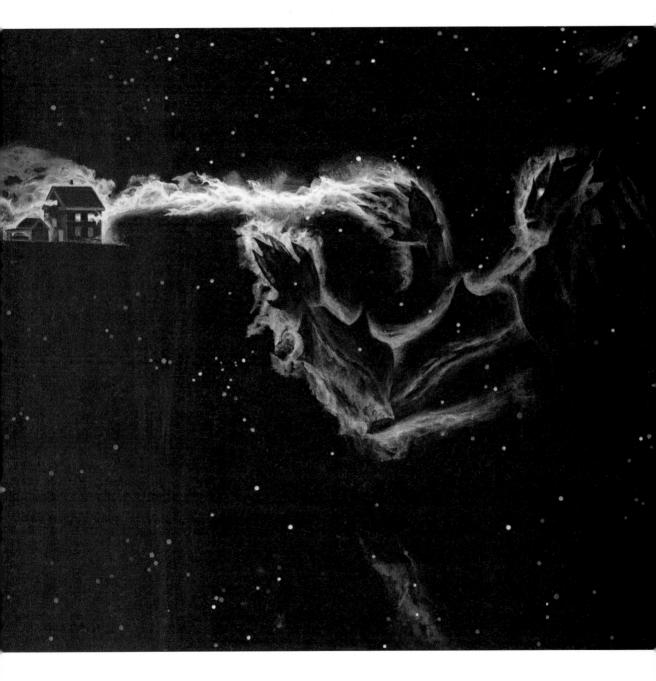

25
LIGHTING THE TORCH

The creative person experiences the
divine grace of being allowed to light
his small torch at the fire of the
Creator. P. B. once dreamed that he
was given this grace. The animal face
in the fire in the form of an eight-
petalled flower signifies enlightenment
and order in the chaos.
Oil, June–September 1974

25
GOTTESFEUER

Der schöpferische Mensch erfährt die
Gnade, dass er eine kleine Fackel am
grossen Feuer des Schöpfergottes
anzünden darf und so seine Welt
erhellen kann. P. B. träumte einmal,
dass ihm diese Gnade geschenkt wurde.
Das tierartige Gesicht im Feuer deutet
auf Erhellung, Ordnung im Chaos hin,
da es wie eine achtstrahlige Blume
komponiert ist.
Öl, Juni–September 1974

76

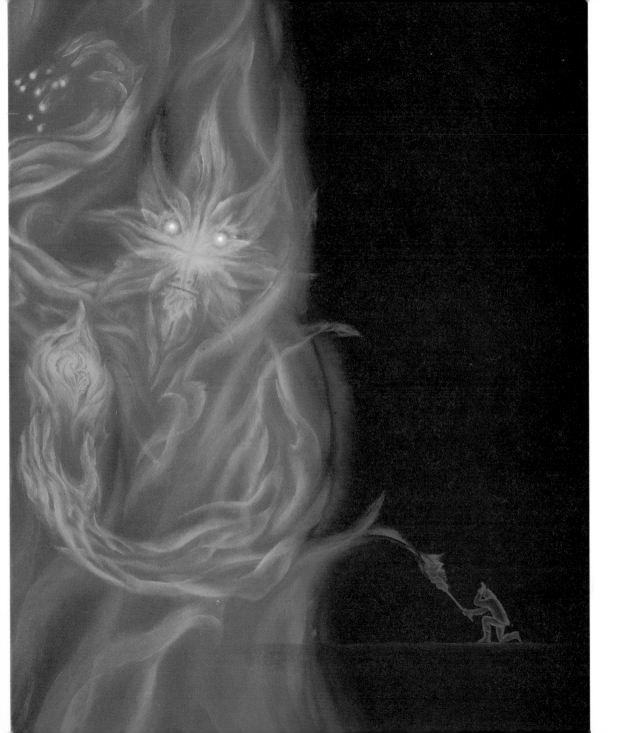

26
HAVING SPEECH

The split man of the 'World's Wound'
has been transformed by the artists's
experience of the unconscious and by
following its inspiration. Blood flows
into the scar so that it could heal. The
eyes look in the same direction and the
man, formerly a despairing mute, now
begins to speak.
Oil, April 1975

26
ZWIEGESPRÄCH

Durch die Hingabe an die Inspiration
des Unbewussten und durch die
Auseinandersetzung mit ihm ist der
‹Gespaltene› (Bild 2) verwandelt. Seine
Narbe wird durchblutet, so dass sie
weiterheilen könnte. Die Augen blicken
in gleicher Richtung, und der vorher
Stumm-Verzweifelte beginnt zu
sprechen.
Öl, April 1975

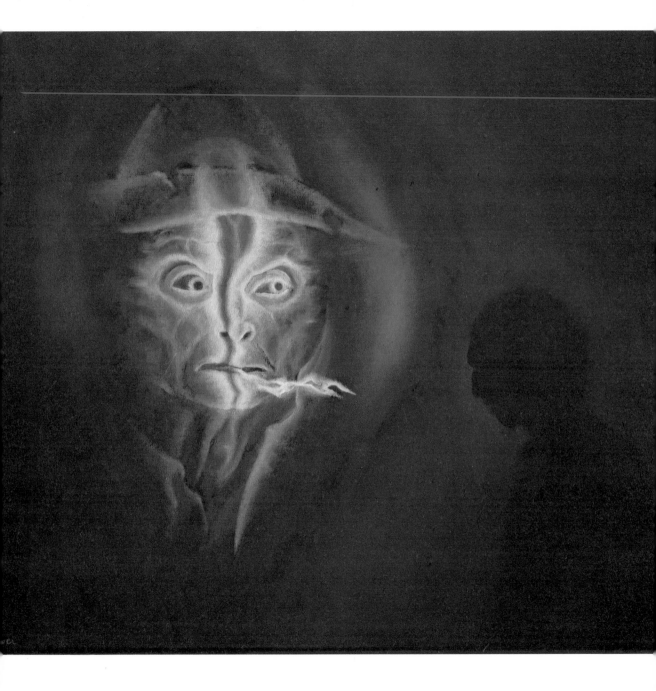

27
IN THE NIGHT OF
13 OCTOBER 1942

This is one of the few paintings which
directly represents a dream. P. B.
dreamed on 13 October 1942 that with
his wife he was climbing a steep,
narrow ramp within the tower of Basel
cathedral. A miraculous being, half fish
and half insect, climbed up beside the
ramp on two threads. At the top it
turned into a fish's head, shining silvery
in every colour. From its mouth
emanated a blue light. Courageously,
Sibylle Birkhäuser stood still, the fish
approached her as if to kiss her and she
became completely illumined by the
blue light. P. B. went on and had to
jump from one platform to another
over the abyss. From the opposite
platform an eye, the eye of God, was
looking at him from a green triangle. It
penetrated him with its overwhelming
light. This dream vision is the
experience of 'vocation'. The anima is
inspired and illumined before the artist
himself.
Oil, September 1975

27
IN DER NACHT VOM
13. OKTOBER 1942

Eines der wenigen Bilder, das ein
Traummotiv direkt wiedergibt. P. B.
träumte, er besteige hinter seiner Frau
auf einer schmalen, steilen Rampe in
dessen Innerem den einen Turm des
Basler Münsters. Ein Wunderwesen,
halb Fisch, halb Insekt, steigt bei der
Rampe an zwei Fäden empor und wird
oben zu einem Fischkopf, der silbern
und in allen Farben schimmert. Aus
seinem Maul strahlt ein blaues Licht.
Sibylle Birkhäuser bleibt mutig stehen;
der Fisch nähert sich ihrem Gesicht, wie
um sie zu küssen; sie wird von seinem
blauen Glanz ganz durchstrahlt.
Weitersteigend muss P. B. einen grossen
Sprung über den Abgrund auf eine
gegenüberliegende Platte wagen. Von
der Platte aus blickt ihn aus einem
grünen dreieckigen Rahmen ein Auge
an – das Auge Gottes! Es strahlt ein
durchdringendes, überwältigendes
Licht auf ihn. Diese Traumvision ist
ein Berufungserlebnis. Die Anima wird
vom Gottesgeist inspiriert und
erleuchtet.
Öl, September 1975

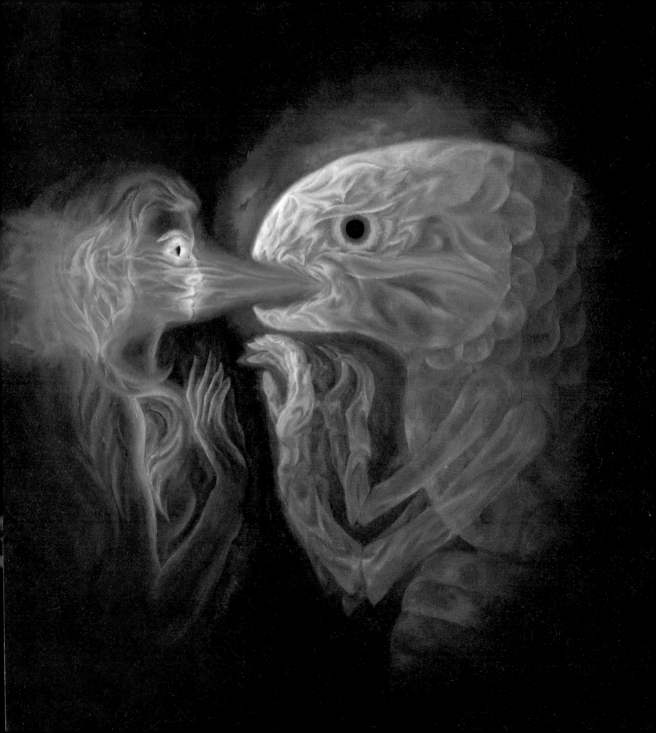

28
SPIRITUS NATURAE

P. B. often dreamed of wild cats and the aura of power shining from them. We often believe they represent the instincts, but they also have a spirit of their own, a way of seeing things in the light of the unconscious psyche. P. B.'s artistic eye could 'project' inner experience in this way, as well as merely registering, and he was able to see the reality of the psyche.
Oil, June 1976

28
NATURGEIST

Immer wieder träumte P. B. von grossen und kleinen Wildkatzen, von ihrer strahlenden, sorglosen Naturkraft. Wir glauben oft, sie stellten das Tierische, den Trieb dar, aber sie besitzen auch einen eigenen ‹Geist›, nämlich eine Art des Sehens, wie es dem Unbewussten eigen ist. Es ist ein Sehen, das Sicht *aussendet,* nicht nur empfängt. Das Künstlerauge P. B.s war von dieser Art, es ‹projizierte› (warf nach vorne) ein Bild von der Wirklichkeit der Seele.
Öl, Juni 1976

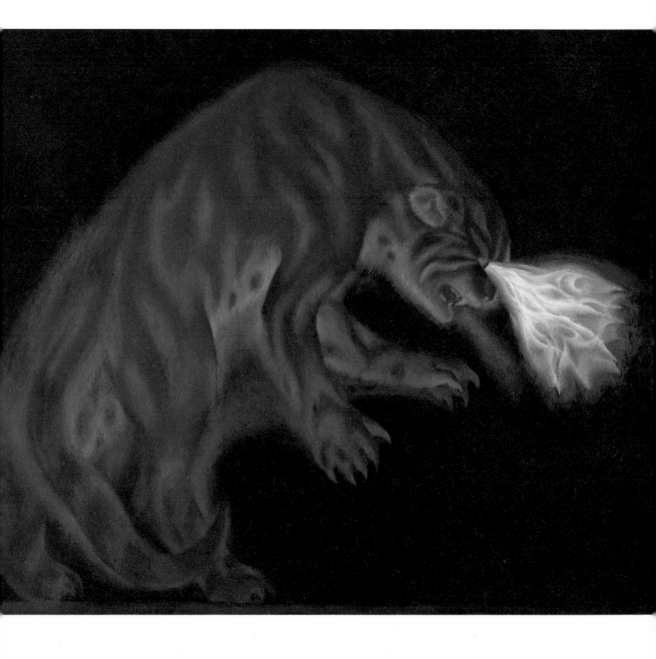

29
LYNX

The creative artist serves a spirit of
nature which tries to manifest itself
through him. But sometimes its
enormous energy is too much for him,
especially when the body becomes
older. P. B. painted this picture, which
is based on a dream, shortly before his
death. The frail human being has to
surrender to the powerful god. The
lynx is a far-sighted creature which can
see in the dark. Its name is related to
'lux' (light).
Oil, September 1976

29
LUCHS

Der schöpferische Mensch dient einem
Naturgeist, der sich durch ihn
offenbaren will; doch manchmal sind
dessen Energieballungen zu viel für den
Menschen, besonders wenn sein Körper
altert. P. B. malte dieses Bild, das auf
einem Traum beruht, kurz vor seinem
Tod. Der irdische Mensch muss sich der
Übermacht des Gottes ergeben. Der
Luchs ist der ‹Weitblickende›, der auch
im Dunkeln sieht. Sein Name hängt
mit ‹lux› (Licht) zusammen.
Öl, September 1976

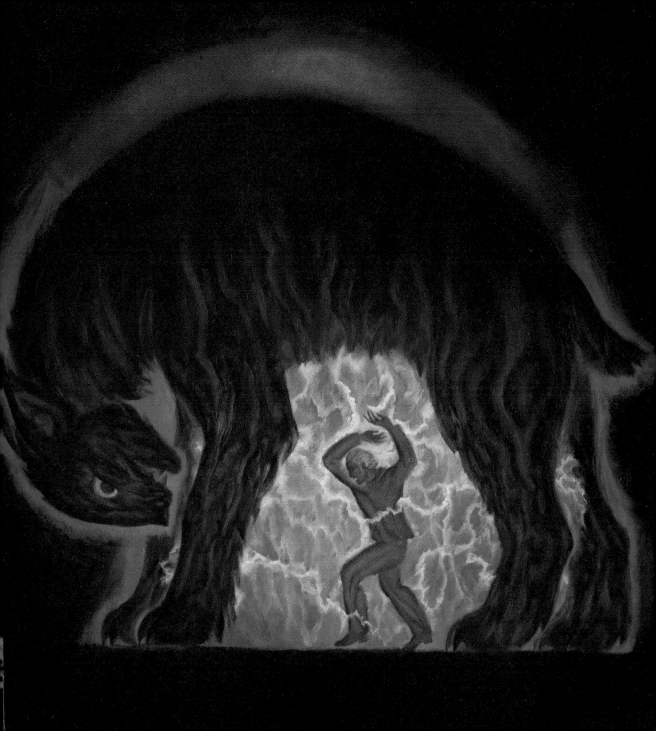

30
IN HIS HANDS

In antiquity the snake was worshipped as a god of time and eternity. It is an incomprehensible, threatening and annihilating spirit which also harbours a secret meaning. In its hands man is helpless, all his values are overthrown (the man is upside down!). The wavelike lines suggest cosmic waves or crystalline patterns in primeval rock, like the 'secret patterns' which our lives follow.
Crayon 1967, lithography 1975

30
IN GOTTES HAND

Die Schlange wurde in der Antike als Gott der Zeit und der Ewigkeit verehrt. Sie ist der Weltgeist, den wir nicht verstehen, der uns oft bedroht, am Ende vernichtet, und in dem doch ein verborgener Sinn wohnt. Der Mensch ist ihm hilflos ausgeliefert, als ob sich in seiner Gegenwart alle Bewusstseinswerte umkehren würden. Die zackigen Wellenlinien vermitteln ein Gefühl kosmischer Wellen oder kristalliner Bildungen im Archat – sie deuten auf ein Muster hin, dem unser Leben folgt.
Kreidezeichnung 1967, Lithographie 1975

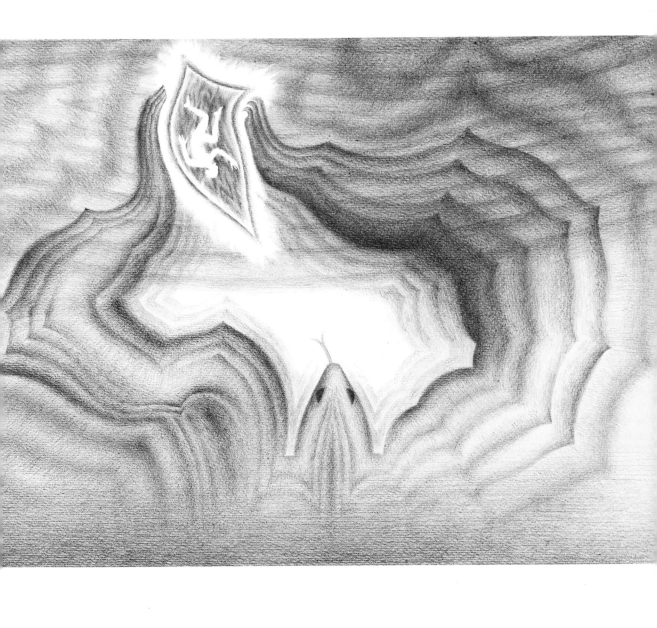

31
DUEL

If we look at our conflicts objectively
(nirdvandva – free of the opposites)
they reveal themselves as part of the
very nature of the psyche, for the
unconscious both does and does not
want to enter into our consciousness.
Here the more human-looking figure in
the monk's habit of renunciation has
the upper hand, since he has the
weapon, a symbol of discrimination,
which his opponent lacks.
Crayon 1969, lithography 1973

31
ZWEIKAMPF

Wenn wir unsere Konflikte objektiv
(nirdvandva – frei von Gegensätzen)
betrachten, enthüllen sie sich als eine
Eigenschaft des Unbewussten selber: es
will und will doch auch nicht in uns
bewusst werden. Der menschenähnliche
Kämpfer in der Mönchstracht der
Weltentsagung siegt, weil er die
Waffe – ein Symbol des Unterscheiden-
und Entscheidenkönnens – besitzt, die
dem Nur-Tierischen fehlt.
Kreidezeichnung 1969, Lithographie
1973

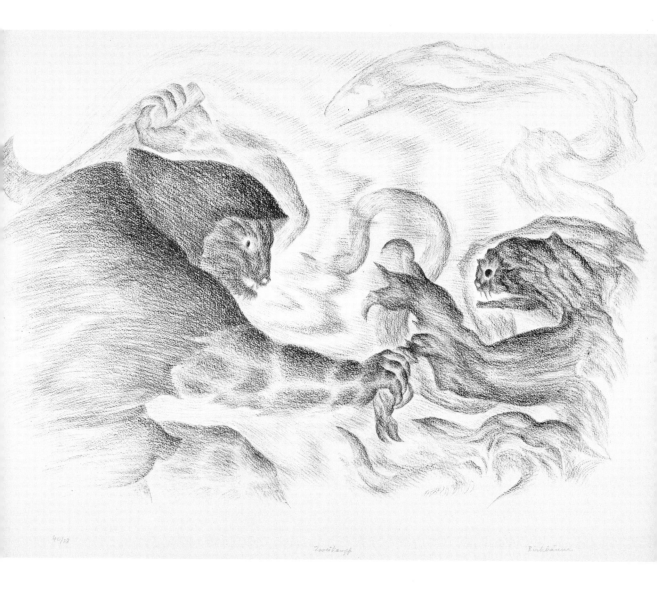

32

THE FOURFOLD FACE

Quaternity, according to C. G. Jung,
always points to inner totality. The
spirit of the universe appears to us to be
unconscious and animal-like, but also
'knowing' in a higher sense of the word.
The spirit casts a dark shadow (the
black sphere behind) and further back
again a new sun is rising, perhaps the
new light of a coming aeon which man
will only see after having gone through
the darkness of the unconscious.
Crayon 1969, lithography 1975

32

VIERÄUGIGER WELTGEIST

Vierheit weist nach C. G. Jung immer
auf Ganzheit hin. Der Geist des
Weltalls erscheint uns unbewusst-
animalisch zu sein und in einem
höheren Sinn ‹wissend› zugleich. Der
Geist hat einen Schatten (die dunkle
Kugel hinter ihm), und noch dahinter
steigt eine neue Sonne empor, vielleicht
das Licht eines kommenden Zeitalters,
das wir erst sehen werden, wenn wir
durch eine grosse Dunkelheit
hindurchgegangen sind.
Kreidezeichnung 1969, Lithographie
1975

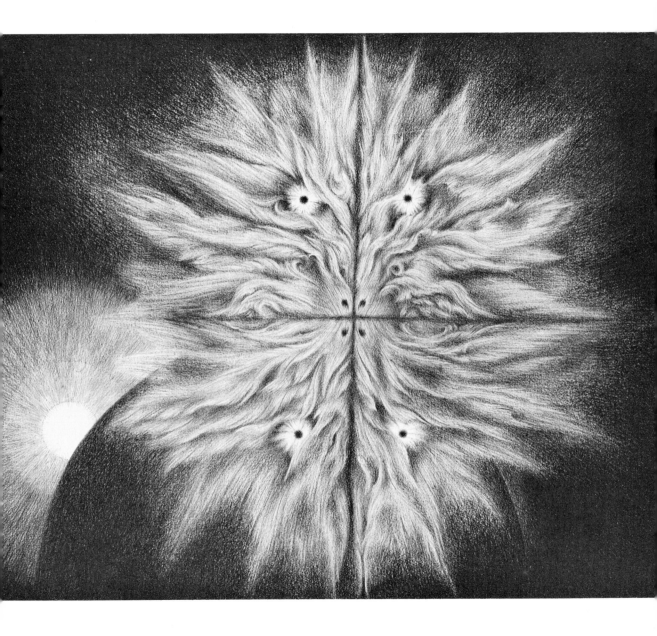

33
CONSTELLATION

This is a dream experience. The
spiralling snake points to the centre.
Among all the thousands of stars in the
sky, folklore says that one is 'our star',
meaning our individual destiny, which
is the consummation of our totality.
Every path and process of life (the
snake) leads to the star, whether we
know it or not. There, in the centre, is
the well of the 'water of life', the life of
the innermost soul.
Crayon 1970, lithography 1974

33
STERNBRUNNEN

Traummotiv. Die spiralig aufgerollte
Schlange weist auf das Zentrum. Unter
den vielen Sternen am Himmel ist nach
dem Volksglauben einer ‹unser Stern›,
das individuelle Schicksal, in dem sich
unsere Ganzheit verwirklicht. Jeder
Lebensweg und Lebensprozess (die
Schlange) führt dorthin, ob wir es
wissen oder nicht. Dort, im Zentrum,
ist der Brunnen, aus dem das Wasser
des Lebens emporquillt.
Kreidezeichnung 1970, Lithographie
1974

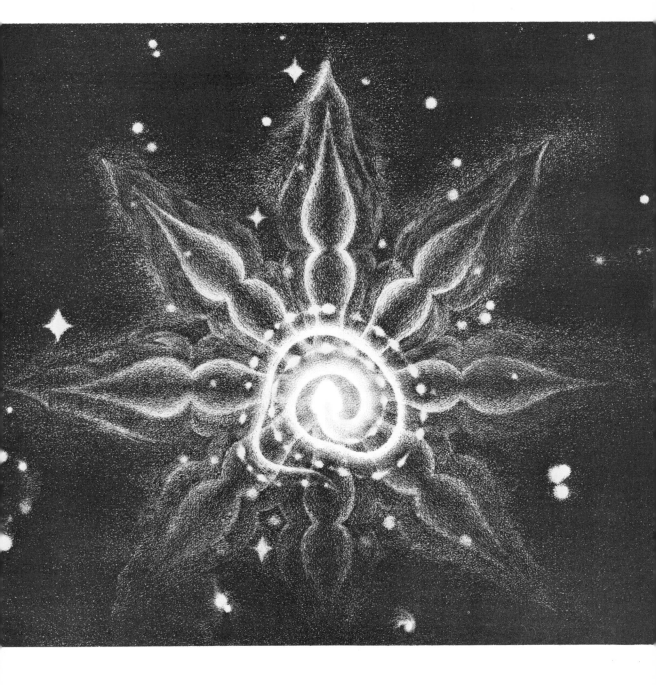

34
SPIRITUS ANIMALIS I

What appears in man to be only wild
instinct has in fact also a divine
spiritual aspect, for the unconscious is
both instinct and spirit. This bear, an
ancient god image, has lights for eyes, it
sheds illumination on the onlooker. On
its forehead it has a third eye which can
see the opposites together in one. The
fur is like flames because this bear is a
spirit, not a physical entity.
Lithography 1972

34
SPIRITUS ANIMALIS I

Was sich im Menschen zunächst als
Trieb ankündigt, enthält neue
Einsicht; denn das Unbewusste ist
Instinkt und Geist zugleich. Der Bär –
ein uraltes Gottesbild – hat Lichter
statt Augen – er strahlt Erleuchtung
auf den Beschauer. Auf der Stirn hat er
ein drittes Auge, das die
Weltgegensätze zusammenschauen
kann. Der Pelz ist wie Flammen
gestaltet, weil dieser Bär kein
Körperwesen, sondern ein Geist ist.
Lithographie 1972

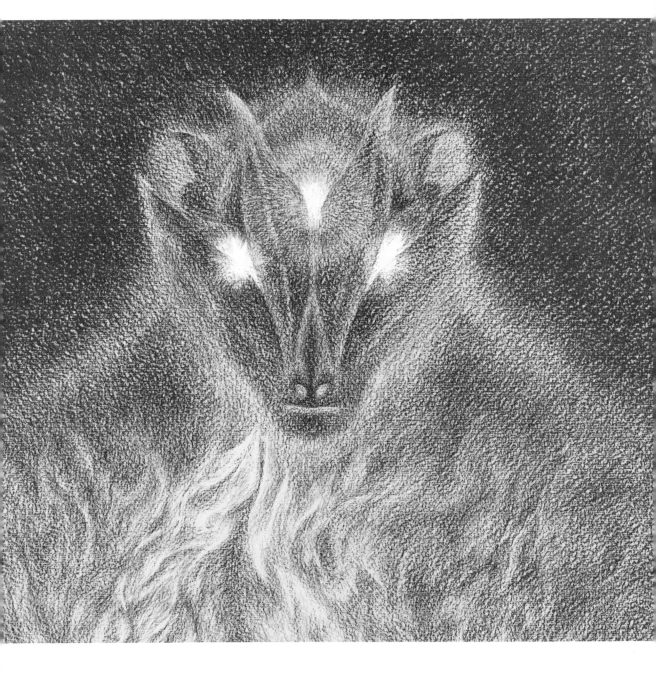

35
BIRTH FROM THE CHRYSALIS

"Suffering is the fastest horse that can
carry us to completion" (Meister
Eckhart). When the soul (anima)
embraces and accepts suffering the pain
reveals itself as the birth pangs of a new
inner being. 'Psyche' in classical Greek
means 'soul' and 'butterfly'. The latter
was a symbol of the soul led by Hermes
after death into the beyond.
Crayon 1971, lithography 1976

35
SCHMETTERLINGSGEBURT

«Leiden ist das schnellste Pferd, das
uns zur Vollendung trägt» (Meister
Eckhart). Wenn die Seele das Leiden
umarmt, entpuppt es sich als
Geburtsschmerz eines neuen inneren
Wesens. Das griechische Wort ‹Psyche›
heisst ‹Seele› und ‹Schmetterling›.
Letzterer ist ein Bild der Seele, wie sie
nach dem Tode befreit, von Hermes
geleitet, davonfliegt.
Kreidezeichnung 1971, Lithographie
1976

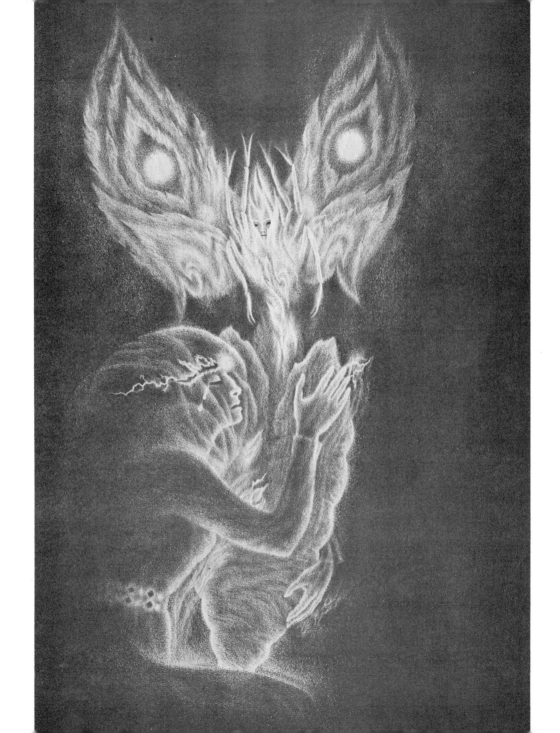

36
THE FLAME DANCER

Now the anima – the 'lady soul' – has
found her own real task: to mediate
and bring to man the divine fire and its
creative power. Like the bearer of the
Grail, or a vestal virgin, she guards the
fire and also plays with it.
Oil 1974, lithography 1975

36
FEUERTÄNZERIN

Hier hat die Anima den Weg zu ihrer
eigentlichen Aufgabe gefunden, als
Vermittlerin des göttlichen Feuers, der
schöpferischen Macht. Wie die
Gralsträgerin oder wie die Vestalin
hütet sie es und spielt auch zugleich mit
ihm.
Ölbild 1974, Lithographie 1975

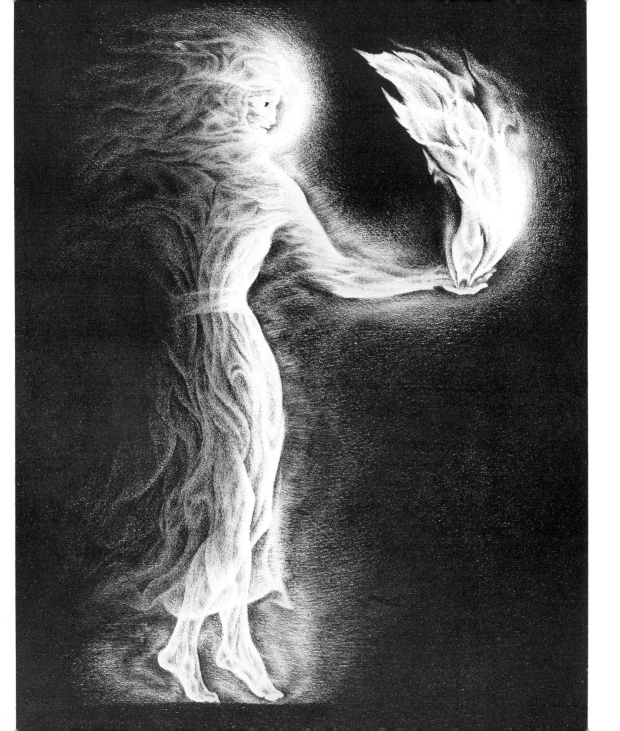

37
ISIS

The 'old woman' reveals her transcendent divine aspect. In the vision of Apuleius (Metamorphoses II) she says about herself: "You see me here … I am nature, the universal mother, mistress of all elements, primordial child of time, sovereign of all things spiritual, queen of the dead, queen of the immortals, the single manifestation of all gods and goddesses there are. My nod governs the shining heights of heaven, the wholesome sea breezes, the lamentable silences of the world below …" Here she shows especially her aspect 'as dread Prosperine to whom the owl cries at night, whose triple face is potent against the malice of ghosts'.
Lithography, February 1976

37
ISIS

Die ‹Alte› offenbart ihre umfassendere göttliche Gestalt. In einer Vision des antiken Schriftstellers Apuleius (Metamorphosen 11, 3) sagt sie von sich aus: «Du bist ich … die Mutter der Schöpfung, die Herrin der Elemente, der Urspross der Jahrhunderte, die höchste der Gottheiten, die Königin des Geistes, die Erste der Himmlischen, die Erscheinung der Götter und Göttinnen in *einer* Gestalt, die ich des Himmels lichtvolle Höhen, des Meeres wohltätiges Wehen, der Unterwelt vielbeweinte Stille durch meinen Wink leite.» Hier zeigt sie besonders Züge der ‹durch das nächtliche Geheul Schauder erregenden Proserpina›, welche ‹den Ansturm der Geister bändigt›.
Lithographie, Februar 1976

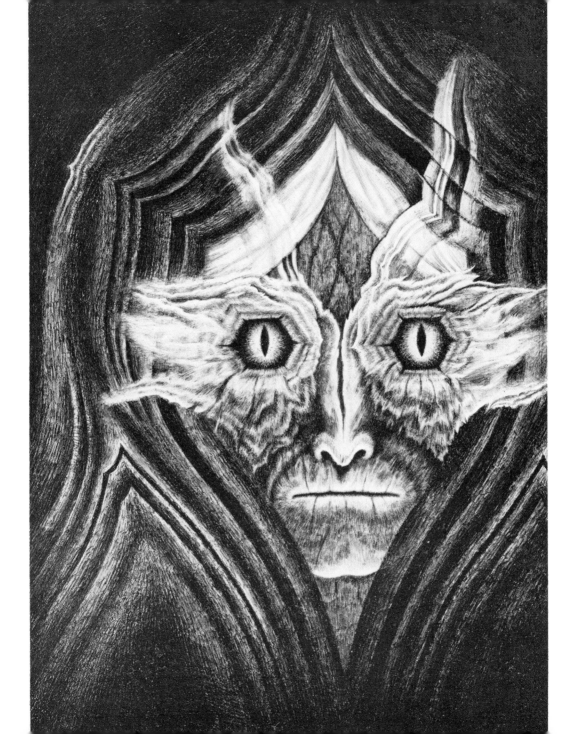

ANALYTICAL PSYCHOLOGY
AND THE PROBLEMS OF ART

Peter Birkhäuser

Jung's discovery of suprapersonal, spontaneous spiritual activity in the unconscious has changed the face of the world – the key note of human existence, as it were –, even if outwardly this change is barely noticeable at the present time.

As a result, Jung has enriched the most varying fields of human intellectual and scientific endeavour, and it is still difficult to foresee how far and where this innovation will lead in the future. In any event, it has shed new light on the problems of art. In fact, I believe that Jung may have shown us the way leading out of the chaos, in which art has lost itself. Originally, figurative representation was magic art, a charm to exercise the spirits, or a means to make the gods visible; a form of worship. It was used for healing and for protection.

In Egyptian and classical antiquity, in the eastern civilizations, as well as in the Christian Middle Ages, art was therefore chiefly a religious instrument. As an individual the artist was hardly known in public. He had to remain in the background and accomplish his tasks along strictly prescribed and dogmatically determined lines.

The art of the Renaissance began to move away from this introverted attitude for which the *inner* image was the essential thing. It abandoned this source of inspiration and in the wake of the great spiritual movement of this time it turned to extraversion. For many people the world of Christian ideas had lost its attraction and no longer provided sufficient possibilities

for expression. The new spirit of the western world was outer oriented, fascinated by the long ignored mysteries of nature. In art, too, attention began to focus on the multitude of external manifestations.

As a result, many artists of those days were also natural scientists. One Renaissance painter claimed that, when he lay down to sleep at night, he felt happy because the following day he would have another opportunity to study 'the divine perspective'. Leonardo da Vinci excelled not only as a great artist, but also as an anatomist, mathematician and engineer; and Michelangelo was so fascinated by the structure of the human body that he devoted many years to its study.

Although church paintings and statues still formed the bulk of art produced at that time, the holy images increasingly resembled studies from nature. The human body with its musculature and positions in space, drapery, animals, plants and background landscapes became ever more important. At the same time, the original content, i.e. Christian mythos, began to recede into the background.

Intoxicated by the pagan world, artists began to represent the gods of antiquity and their myths instead of their own. Soon thereafter, the Reformation began to make tremendous inroads on the world of dogmatic Christian concepts, concretizing this onslaught by actual iconoclasm. In his Bailey Island Seminars[1] Jung said: "The Catholic Church is a way to live the unconscious, and the dogmas of the Catholic Church contain the entire history of the unconscious objectified. Whatever they represent as happenings is what happens in the unconscious."

The growing neglect of this inner world of images in the six-

teenth century gave rise to a secret countercurrent: the symbolic fantasies of the alchemists. Jung discussed this in his Zarathustra Seminar[2], and he described the unbearable tension created by the loss of confession and absolution. For this reason, the Wise Old Man was said to have come to the alchemists – here a personification of the unconscious – advising them to make pictures, in order to solve their problems by the inner priesthood.

However the alchemists' introverted search and groping for a continued development of the mythical concepts had a very small following. Grünewald, Bosch and Dürer, for example, were exceptions.

The sensitive barometer of art clearly indicated how the passion for representation of the outer world continued to grow in the sixteenth and seventeenth century. It seemed as though artists were insatiable for material stimuli. The theory of shading was added to perspective, i.e. through artful lighting and appropriate casting of the shadow, artists learnt to throw the spaciousness and the three-dimensionality of the body into even fuller relief. Anatomic features became fleshly – as with Rubens –, and the sensuous pleasure in all outer objects found expression in innumerable beautiful still lifes of venison, laden tables, fruit, fish, flowers, musical instruments, etc., etc. There were even painters specialized in poultry yards! Domestic, social and military scenes became themes, and portraits played an increasingly important rôle. Man's larger environment also came within the purview of art: towns, the sea, or landscapes in different seasons. The inner landscape, on the other hand, was increasingly lost from sight.

Whenever inner objects were painted at all, they were turned into cool, traditional church pictures, whose exaggerated materiality threatened to obliterate the symbolical content; or the artists fled to the alien field of ancient mythology. Even highly introverted and religious artists like Rembrandt moved away from emphasis on symbolical themes and turned to that of light.

Whereas the approach was still serious, heavy and at times naïve in the seventeenth century, the originally passionate attention devoted to the outer turned to externality in the eighteenth. Elegance, *raffinement* and a highly developed craft gave rise to very much beautiful portraits, landscapes and the like, but the altar paintings of that epoch reveal how cut off artists were from their mythological background. The Maries are no more than piquant ladies, and the angels are amoretti. True emotion, of the kind expressed in Gothic altar paintings, does not come through anywhere because the driving force of the images from the unconscious is lacking.

People of that period had largely lost contact with the inner world. Rationalism led to growing one-sidedness and, accompanied by psychic split and tensions, it finally culminated in the tremendous explosion of the French Revolution.

The Revolution managed to do away with a lot that was outdated and life destroying, but it also led to the overvaluation of human reason: in 1793, the 'Déesse Raison' replaced the Virgin Mary in Notre Dame of Paris and the 'cult of reason' was introduced. What a fateful moment!

With a great deal of foresight, Shelley wrote in those years that cultivation of the natural sciences, which helped man to gain

mastery over his external world, required a corresponding extension of his inner world to prevent man, who had enslaved the elements, from becoming a slave himself.

At that time Johann Heinrich Füssli, a Swiss artist from Zürich, painted a picture that grasped the psychic state of the time with prophetic vision: it displays a sleeping woman in a tortuous position with a nightmare on her breast. The wild, outsized head of a blind horse appears behind her bed. The picture suggests that psyche, in a state of unconsciousness, is tortured by a bad dream and is threatened by the blind frenzy of the unconscious. – Prints of this painting were distributed widely in those years, but it was so poorly understood that it was sold in France with an obscene poem in lieu of a legend. The Revolution ended in a blood bath and the dictatorship of a power-drunk Napoleon. People were further than ever from being able to relate to the psyche.

The art of that time has something of a stage effect; it is a cold imitation of antiquity. The Jacobine painter David, a sort of propaganda minister for the revolutionary government, even wanted a law passed, which would have obliged people to wear Roman dress! To a disciple whom he wanted to incite to paint, he wrote: "Vite, vite! Feuilletez votre Plutarque!" The disciple was to look up in the classics what he had to paint.

A countermovement made itself felt in German romantic art, but it was too weak and was intellectually too ill equipped to overcome the materialist prejudices against psyche. Thus, for example, a group of artists, called the 'Nazarenes' sought refuge in a regression, by leading a sort of monastic life. They tried to acquire a feeling for medieval piety and introspection

and imitated fifteenth-century altar paintings, but obviously their experiment was condemned to failure.

Caspar David Friedrich's landscape paintings, in which he sought to represent the divine aspect of nature, constitute a solitary bold and extremely positive attempt to go beyond the growing rationalism. But he remained alone and misunderstood. When he died in 1840, art had on the whole become petrified in photographic copies of the external world and in lifeless imitations of former styles.

Goethe's Faust fantasy rises like a lone mountain out of that epoch addicted to reason. When Goethe was asked – with certain undertones of reproach – how it was to be understood, he answered: "The more a poetic production is incommensurable with and unintelligible to reason, the better it is!"

In the light of the general utilitarian attitude and the one-sided preponderance of rationalism, the irrational found fewer and fewer outlets for expression; for, even the religious forms were devoid of life. The soul remained banished to the underworld.

Since the powers of the unconscious could, however, not be spirited away, they began to undermine the structure of reason from within. Artists began to react against the Renaissance ideal, which continued to predominate but had become worn and lifeless: around 1860, the Impressionists made their appearance. *Impressionism* is an improper designation, which stuck accidentally, because a painting in an exhibition was entitled 'impression'. The members of the movement called themselves *Divisionistes,* because they divided the appearance of the outer world into their colour elements. One group of *Divisionistes* even called themselves *Pointillistes,* because they dissolved their

representations into screen-type colour points. The Impressionists emphasized their lack of interest in the content of paintings; the colour aspect was much more important to them. This process of disintegration continued: at the turn of the twentieth century, we witnessed the development of Cubism. It reduced the outer forms to their basic geometrical elements. Abstract art which dropped both outer and inner objects, was now just around the corner. By the time of the First World War, the traditional integral image of the outer world had disappeared.

What has been outlined here is, of course, only a generalized description of this development. In actual fact, many of these currents existed side by side and overlapped.

According to Jung, this process was essentially a devaluation of the outer object. He claimed that art constitutes a counterweight to the trend of the times.

Another factor that contributed to the devaluation of a too extraverted art was the invention of photography. As an even more mechanical visual medium, photography in combination with its capacity for mass reproduction dealt the deathblow to a naturalist style of painting completely devoid of spiritual vitality. The devaluation and dissolution of the image of the outer world paved the way to the inner image.

Without this development, detachment from the Renaissance ideal would have been impossible. This was exemplified by such nineteenth-century artists, as Klinger, Böcklin, or Thoma, who tried to deal with inner motives in the traditional way. Their painting remained partial to allegories, which were represented quite concretely just like an outer reality.

The turning away from the outer, initiated by the pioneers of modern art, was a hopeful movement that opened new perspectives. The question was whether it would give access to the inner world, whether this was possible without a positive attitude to the psyche. – The break with the outer did not necessarily imply a return to the inner. The prevailing nineteenth-century materialistic attitude with its devaluation of the psychic element was ill equipped to accomplish such a feat. It blocked the passage to the inner world.

In his Zarathustra Seminar Jung described how the passage to the unconscious is obstructed in modern man. In order to get relief the unconscious therefore erupts like a volcano, issuing forth chaotic lava.

Such outbreaks are visible in a number of the more recent art forms, as, for instance, in Tachism with its representation of the unformed and shapeless. The violent, volcanic eruption is expressed in a process, whereby guns are used to shoot at filled paint pots, whose content is thus splattered on the canvas.

Another procedure consists in pouring petrol over applied blotches of paint which is lit; the fire then eats holes and bizarre shapes out of the canvas.

Such accidentally created pictorial effects may stimulate the imagination, but they are hardly sufficient to express the contents of the unconscious. For, our dreams and fantasies often present us with very impressive, complete and clearly outlined figures and with dramatic action, whose scenery is tremendously rich and strange. In his Dream Seminar[3] Jung said:

"One is impressed by the fact that the unconscious of man is a sort of mirror of great things." – However, all too frequently

materialistic prejudices, cynisism and fear block access to the inner world, and the most widely recognized psychologies are incapable of seeing its hidden values or consider them as falsified sexuality and the like. The psyche cannot flourish under such influences.

A dangerous state of explosive inner tensions was created by these attitudes, as a result of which the collective unconscious was somehow no longer properly connected to life.

Many decades ago Jung therefore prophesied that 'there will be a worldwide upheaval'[4], and it would seem that this has already come to pass.

It is often said that the chaos in present-day art is in fact a reflection of this inner chaos. But being drowned in chaos does not mean a representation of it. Instead one needs distance, a firm conscious standpoint outside and the ability to intervene creatively. Moreover, a mere passive dwelling in disintegration is too negative.

Personally, I believe that it would be more constructive to look for the signs of a new order in the shapeless mass of 'chaotic lava'. A secret longing to get beyond the state of dissolution is already quite manifest.

The proper attitude makes it possible to be caught up in the currents of the unconscious, without, however, losing one's own standpoint. In fact, it is the *only* way to recognise and pin down what is valuable. The psychic material coming from the unconscious must after all be observed and sifted. What would a dream be unless it was confronted with a perceiving and conscious ego?

In his Zarathustra Seminar[5] Jung described the great danger,

to which many people are exposed owing to the loss of religion, the loss of contact with the depths of the unconscious:

"That is what people don't know: they don't know that they are exposed naked to the unconscious when they can no longer use the old ways ... They are defenceless and have to repress their unconscious, they cannot express it because it is inexpressible ..." – The unconscious has become inexpressible for those who are caught in rationalism and have therefore barricaded all avenues leading to it.

Today's artists would thus do well to find some access to the inner world both for themselves and for their fellowmen, to provide a valve, or to be a vessel that can receive the contents of the unconscious. They should try to capture the psychic forces in pictures. This implies that they must have experienced them as being alive and spontaneous.

A painter once dreamed that a gigantic, wild hunter dressed in green – a Wotan-like figure – made his way into his workshop demanding to be painted.

Here we get a clear picture of the spontaneous activity of unconscious figures, how they appear to the individual, wanted to be seen and held fast.

Or, someone dreamed he was in an endless, labyrinthian cave system. He knew that someone else lived there, a powerful, half animal, half godlike figure, looking for *him*. He was afraid of the creature, fled, but at the same time he was attracted by it. This was the embodiment of the creative demon in the unconscious and shows how he desires contact with man, how he pursues him along tortuous paths. He is like the immortal, divine brother of the Dioscuri.

If it is ignored and excluded from life, this power can, however, also turn into a destructive demon.

A gifted man, who was in danger of exploiting the contents of the unconscious for selfish purposes, dreamed of someone, who had discovered a huge, ancient, subterranean vault completely filled with golden yellow honey. He forced his way in, opening the gate, but the honey poured out with such vehemence that the glutton drowned in it. Then the dreamer himself descended into the vault to bring in the loot, but once there, the devil came upon him and to save himself he had to fight for his life.

In this dream we see how the hidden treasures of the unconscious can also do harm. Their potential misuse calls up the devil.

It is always extremely interesting to see how the unconscious reacts to these problems and tunes in to the individual case. In dreams it describes the specific situation that often seems so obscure on the conscious level, inspiring, encouraging, confirming at times and then again criticizing warning or rejecting.

One woman, who was confronted with a creative problem and required encouragement, dreamed that a whole lot of golden, ripe apples were hanging from the trees in her garden. In this case, productivity is pictured as something valuable that has matured in the unconscious.

Conversely, someone else, who was trying to evade a spiritual task, dreamed that the produce of his garden was rotting away because he had failed to pick it.

A man, who was still unaware of his psychic potential dreamed he had discovered a marvellous, strange, richly decorated treasure chest in his cellar. Another frequent dream motif is the

big house, in which hitherto unknown rooms with valuable objects are found.

A woman in analysis, who ultimately became an analyst herself, dreamed – many years before – that she had discovered a healing spring in an underground cave, but that it would take prolongued and patient work until it could be tapped.

Another man, engaged in writing, had committed the error of commenting ironically on a very serious matter. He dreamed a great woman artist, a painter of mythical fantasies, had died, because someone had written cynically about her pictures. This dream made the writer aware of the fact that the artist would die in him unless his consciousness responded with seriousness toward the images of the unconscious.

All the dream images mentioned show clearly that the more powerful, superior and precious values may reside in the unconscious and how the ego may be at the receiving end. They also make us realize that the ego needs to have a proper, modest attitude to be able to benefit from these treasures and that it has to be willing to make efforts and sacrifices like in a fairy tale, where the hero has to serve and to subordinate himself. He has to sacrifice all kinds of aspirations and to accomplish often arduous and dangerous tasks until he is awarded the longed-for treasure.

Perhaps the effort required of today's artist is the elaboration of a new form of expression that does justice to the contents of the unconscious. This involves a struggle to make visible that which is almost inexpressible. The more serious the painter's attitude toward the inner images, the greater will be his desire to give form to them to the best of his abilities.

When around the turn of the century modern art abandonded all traditions artists also turned away from the traditional techniques of their craft.

Actually, the traditional draughtsmanship, learnt at great pains through careful training in figurative drawing, perspective, etc., was not to be rejected as such, but only the abuse, to which the nineteenth century had subjected it.

To give up this inherited endowment, as well as knowledge and the skill might, however, seem questionable. Yet, one cannot overlook the fact that it had become the medium of expression of an increasingly onesided and extraverted art – to the point, where it almost became a scientific instrument – to capture every detail of the outer. The danger of this classical technique is that inner subjects might be presented in an excessively materialized fashion and thus be falsified.

On the other hand it seems hardly satisfactory to confine oneself to the described modern variety of accidental figures and the kind of shapelessness resulting from colour coagulations and the like. This would amount to roughly the same as an assumption that the *discovery* of a strangely grown root was an expression of the unconscious. It is more likely that such stimuli to the imagination are only the basis, something like the *prima materia,* from which the valuable element has to be distilled by painstaking work.

What I have tried to describe makes it clear that art today cannot be considered merely from the esthetic standpoint. It is not an end in itself according to the motto of art for art's sake, but should again be looked upon as an effort to give expression to new, unknown, and urgent psychic contents. The ego must

be able to behave in a receptive manner. This requires a religious attitude – religion in the sense of a careful observation and consideration of psychic factors.

Whereas the religious painters of old followed dogmatically sanctioned ideas, the artist of today is completely on his own with his experience and exposed to all sorts of errors.

In 'Psychology and Religion'[6] Jung wrote: "A dogma is always the result and fruit of many minds and many centuries, purified of all the oddities, shortcomings, and flaws of individual experience. But for all that, the individual experience, by its very poverty, is immediate life, the warm red blood pulsating today. It is more convincing to a seeker after truth than the best tradition."

With this type of individual experience something like the primordial state of affairs is being reestablished, as when in former times visions revealed the inner world. It is a new beginning.

Jung looked upon himself primarily as a physician. However, it has become increasingly clear that he not only cured individual patients, but that he was the healer of a whole epoch. By helping many people to relate to the creative, ordering and leading side of their souls, he placed the problem of psychic suffering in a much broader context. In his view, suffering is thus not so much a disease than a being cut off from one's essential nature and from one's own destiny.

This great accomplishment of Jung's rescues man from the wretched and hopeless narrowness of the materialistic Weltanschauung and gives him the possibility of experiencing himself the fateful power that lends true meaning to life.

116

The psychic element cannot survive in an atmosphere of rationalism that weighs like a stone on the seedling, the creative germ that would like to grow in the psyche. Jung has removed this load. He not only described the spiritual instinct of the unconscious in theory, but also showed us examples of its activity, and allowed his own life to be shaped by it.

In this respect, Jung can indeed be a model for the modern artist, who is in search of a path to the treasure room of his soul.

In describing its contents Jung comforts us as follows[7]: "It seems to me that nothing essential has ever been lost, because its matrix is ever present with us and from this it can and will be reproduced if needed."

Zürich, 6 June 1970 Translated by Ruth E. Horine

Notes

1 Jung, C.G.: Dream Symbols of the Individuation Process. Seminar held at Bailey Island, Maine 1936, p.83. Private Copyright.

2 Jung, C.G.: Psychological Analysis of Nietzsche's Zarathustra. Notes on the seminar, vol.2, p.208. Zürich 1934. Private Copyright.

3 Jung, C.G.: Dream Analysis, Seminar on Analytical Psychology, 3rd ed., vol.2, p.116. Zürich 1929–1930. Private Copyright, 1958.

4 Jung, C.G.: Interpretation of Visions. Seminar on Analytical Psychology, part 8, p.92. Zürich 1933.

5 Jung, C.G.: Psychological Analysis of Nietzsche's Zarathustra. Notes on the Seminar, vol.9, p.33. Zürich 1938. Private Copyright.

6 Jung, C.G.: Psychologie und Religion, p.92. Rascher, Zürich 1947.

7 Serrano, M.: C.G. Jung and Hermann Hesse, p.86. Routledge & Kegan Paul, London 1966.

38
PORTRAIT OF C.G. JUNG

An example of the previous period in
P.B.'s art. This drawing was a
commission for a birthday present for
Jung, who considered it the best
portrait of him extant.
Chalk, April 1958

38
PORTRÄT VON C.G. JUNG

Ein Beispiel für die Malerei, wie
Birkhäuser sie in seiner früheren
Schaffenszeit gepflegt hat. Die
Zeichnung war eine Auftragsarbeit. Sie
diente als Geburtstagsgeschenk für
C.G. Jung, der fand, sie sei das beste
Porträt, das von ihm bestehe.
Kreide, April 1958

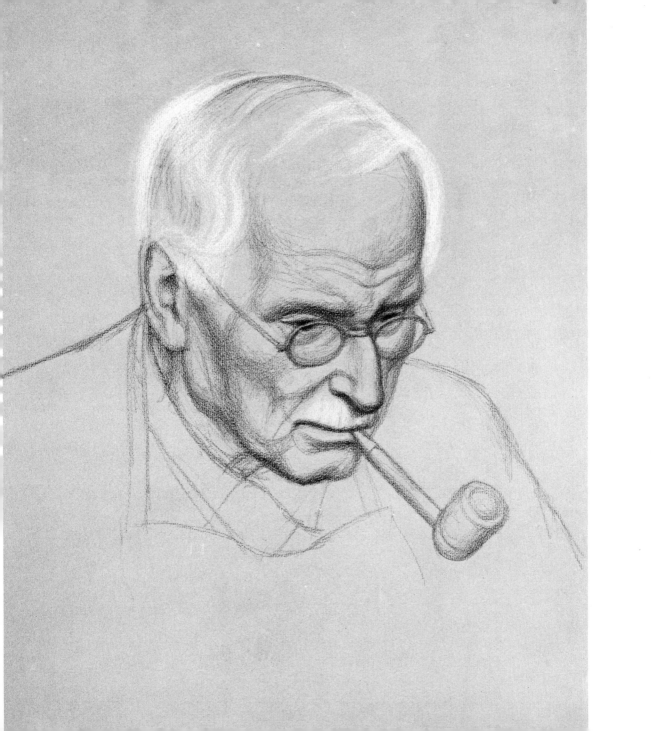

ANALYTISCHE PSYCHOLOGIE
UND DIE PROBLEME DER KUNST

Peter Birkhäuser

Jung hat durch seine Entdeckung einer überpersönlichen, unabhängigen geistigen Tätigkeit im Unbewussten gewissermassen allem ein anderes Vorzeichen gegeben, wenn dies auch an der Oberfläche unserer Zeit noch wenig sichtbar sein mag. Er hat damit die verschiedensten Gebiete der Geistes- und Naturwissenschaften befruchtet, und es ist noch gar nicht abzusehen, wie weit und wohin diese Erneuerung in Zukunft dringen wird. So ist durch ihn auch neues Licht gefallen auf die Probleme der Kunst. Ja, ich glaube, dass er den Weg gezeigt hat, der aus dem Chaos herausführt, in dem die Kunst sich verloren hat.

Ursprünglich war das bildliche Darstellen etwas Magisches, ein Zauber, um Geister zu bannen, oder ein Mittel, Götter sichtbar zu machen; eine Art von Gottesdienst. Man suchte sich zu heilen und zu schützen damit. So war im alten Ägypten, im klassischen Altertum und in den östlichen Kulturen die Kunst vor allem ein religiöses Werkzeug, wie auch noch im christlichen Mittelalter. Der Künstler trat als Individuum kaum in Erscheinung; er hatte zurückzustehen und die meistens genau vorgeschriebene, dogmatisch festgelegte Aufgabe zu erfüllen.

Von dieser introvertierten Haltung, in der das *innere* Bild das Wesentliche war, begann sich die Kunst der Renaissance hinwegzubewegen. Sie kehrte sich von jener Quelle der Inspiration ab und ging als ein Teil der allgemeinen grossen Geistes-

strömung jener Zeit auf die Extraversion zu. Die Welt der christlichen Vorstellungen hatte für viele an Anziehungskraft und an Ausdrucksmöglichkeit verloren, und der veränderte abendländische Geist wandte sich nach aussen, fasziniert von den Geheimnissen der lange missachteten Natur. Auch in der Kunst floss das Interesse dem ganzen Reichtum der äusseren Erscheinung zu. So waren manche der damaligen Künstler zugleich Naturwissenschafter. Ein Renaissance-Maler sagte, wenn er sich abends schlafen lege, so fühle er sich glücklich, weil er am nächsten Tage ‹wieder die göttliche Perspektive› studieren dürfe. Leonardo da Vinci zeichnete sich nicht nur als grosser Künstler aus, sondern auch als Anatom, Mathematiker und Techniker. Und Michelangelo war so fasziniert vom Bau des menschlichen Körpers, dass er viele Jahre an dessen Studium wandte. Obwohl man noch meistens Gemälde und Statuen für Kirchen schuf, näherten sich die heiligen Bilder mehr und mehr schönen Naturstudien an. Der menschliche Körper mit seiner Muskulatur und seinen Stellungen im Raum, Faltenwürfe, Tiere, Pflanzen und die Landschaften des Hintergrundes wurden immer wesentlicher. Der ursprüngliche Inhalt, der christliche Mythos, begann daneben zurückzutreten. Begeistert von heidnischer Weltlust, stellte man antike Götter und ihre Sagen dar – anstelle der eigenen. Bald sollte dazu noch die Reformation eine gewaltige Bresche in die Welt der christlichen dogmatischen Vorstellungen schlagen und diesen Angriff handgreiflich mit den Bilderstürmen verwirklichen.

Im Seminar von Bailey Island sagte Jung[1]: «Die katholische Kirche ist eine Art, das Unbewusste zu leben, und die Dogmen

der katholischen Kirche enthalten objektiviert all die Geschichte des Unbewussten. Was immer sie auch repräsentieren und was geschieht, ist das, was im Unbewussten geschieht.» Die zunehmende Abwendung von jener inneren Bilderwelt im 16. Jahrhundert brachte eine geheime Gegenströmung an die Oberfläche: die symbolischen Phantasien der Alchemisten. Jung spricht hierüber im Zarathustra-Seminar[2] und beschreibt die unerträgliche Spannung, welche entstanden sei durch den Verlust der Confessio und der Absolution. Deshalb sei zu den Alchemisten der weise alte Mann gekommen – hier eine Personifikation des Unbewussten – und habe ihnen geraten, sie sollten Bilder machen, um ihre Probleme durch die innere Priesterschaft zu lösen. Das introvertierte Suchen der Alchemisten und ihr Tasten nach einer Weiterentwicklung der mythischen Vorstellungen hatte jedoch im allgemeinen wenig Nachfolge gefunden. Ausnahmen waren zum Beispiel Grünewald, Bosch und Dürer.

Das empfindliche Barometer der Kunst zeigt nun deutlich, wie im Laufe des 16. Jahrhunderts und im 17. die Leidenschaft für die Darstellung des Äussern noch mehr zugenommen hatte. Man konnte sich kaum mehr sättigen an all den stofflichen Reizen. Zur Perspektive war die Schattenlehre getreten, das heisst, man lernte durch kunstvolle Führung der Beleuchtung und den gesetzmässigen Schattenwurf die Räumlichkeit und Rundung der Körper noch mehr hervorzuheben. Das Anatomische wurde zum Fleischlichen – wie etwa bei Rubens –, und die sinnliche Freude an allem Äussern, Gegenständlichen schlug sich nieder in zahllosen schönen Stilleben von Wildbret, gedeckten Tischen, Früchten, Fischen, Blumen, Musikinstru-

menten usw. Es gab sogar Spezialisten für die Darstellung von Hühnerhöfen! Häusliche, gesellschaftliche und militärische Szenen wurden zum Thema, und das Porträt spielte eine immer grössere Rolle. Auch die weitere Umgebung des Menschen rückte in das Blickfeld: Städte- und Marinebilder oder Landschaften in den verschiedenen Jahreszeiten. Aber die innere Landschaft verschwand mehr und mehr. Malte man innere Gegenstände, dann waren es kühle, traditionelle Kirchenbilder, deren übertriebene Stofflichkeit den symbolischen Inhalt zu verdecken droht, oder man flüchtete sich in das fremde Gebiet antiker Mythen. Sogar bei einem so introvertierten und religiösen Künstler wie Rembrandt bewegte sich die Betonung vom symbolischen Thema weg und auf das Licht zu. Während im 17. Jahrhundert noch alles ernsthaft, schwer und zuweilen naiv war, wurde im 18. jene ursprünglich leidenschaftliche Zuwendung zum Äussern zur Äusserlichkeit. Eleganz, Raffiniertheit und ein zum höchsten entwickeltes Handwerk brachten zwar wunderschöne Bildnisse, Szenerien und dergleichen hervor, aber ein Altarbild jener Epoche enthüllt die Abgeschnittenheit vom mythischen Hintergrund. Diese Marien sind bloss noch pikante Damen, und die Engel werden zu Amoretten. Nirgends mehr ist eine Ergriffenheit zu spüren wie etwa im Ausdruck eines gotischen Altarbildes. Die Stosskraft der Bilder aus dem Unbewussten ist daraus verschwunden. Die Menschen jener Zeit hatten schon weitgehend den Kontakt mit der inneren Welt verloren. Die Einseitigkeit einer rationalistischen Einstellung wuchs und damit die seelische Spaltung und Spannung, welche sich dann in der gewaltigen Explosion der Französischen Revolution Luft machte. Viel

Überholtes und Lebenswidriges wurde davon weggesprengt, aber auch der Weg freigelegt für eine Überschätzung der menschlichen Vernunft: 1793 wurde die ‹Déesse Raison› in der Notre Dame zu Paris an die Stelle Marias gesetzt und ein ‹Kultus der Vernunft› eingeführt. – Ein schicksalhafter Augenblick!

Bald danach schrieb Shelley weitblickend, die Pflege der Naturwissenschaften, welche die Herrschaft des Menschen über die äussere Welt gebracht, erfordere eine entsprechende Ausdehnung der innern Welt, damit der Mensch, der die Elemente zu Sklaven gemacht, nicht selbst zum Sklaven werde. Und der Zürcher Künstler Johann Heinrich Füssli malte damals ein Bild, das die seelische Situation der Zeit in prophetischer Schau erfasste: Eine schlafende Frau, in gequälter Stellung liegend, auf deren Brust ein Nachtmahr sitzt. Hinter ihrem Bett erscheint der wilde, riesige Kopf eines blinden Pferdes. Das Bild deutet an, wie die Seele, bewusstlos, von bösem Traum gequält und von der blinden Raserei des Unbewussten bedroht ist. Dieses Gemälde war als Kupferstich in den Revolutionsjahren sehr verbreitet, aber man begriff es so wenig, dass es in Frankreich mit einem daruntergesetzten obszönen Gedicht verkauft wurde. Die Revolution führte dann zu einem Blutbad und zum Machtrausch Napoleons. Man war weiter als je von einer Beziehung zur Seele entfernt.

Die Kunst dieser Zeit nahm etwas Kulissenhaftes an, ein kaltes Nachahmen des Altertums. Der jakobinische Maler David, eine Art von Propagandaminister in der Revolutionsregierung, wollte sogar einmal erzwingen, dass jedermann altrömische Kleider trage! Und David schrieb einem Schüler, den er zum

Malen anregen wollte: «Vite, vite! Feuilletez votre Plutarque!»
Der Schüler musste also in einem Buch des Altertums nachlesen, was er zu malen hatte.

In der Kunst der deutschen Romantik zeichnete sich eine Gegenbewegung ab, doch war sie zu schwach und besass noch nicht das geistige Rüstzeug, welches die Überwindung der materialistischen Vorurteile gegen das Seelische ermöglicht hätte. So flüchtete sich zum Beispiel die Künstlergruppe der ‹Nazarener› in eine Regression. Sie zog sich in eine Art von Klosterleben zurück, versuchte, mittelalterliche Frömmigkeit und Innerlichkeit nachzuempfinden, und malte Altarbilder, die denen des 15. Jahrhunderts glichen, ein Versuch, der natürlich zum Scheitern verurteilt war.

Ein einzelnes, kühnes, äusserst positives Unternehmen, das über den wachsenden Rationalismus hinausführte, war Caspar David Friedrichs geniale Landschaftsmalerei, in der er das Göttliche in der Natur darzustellen suchte. Aber er blieb allein und unverstanden. Als er 1840 starb, war die Kunst im allgemeinen bereits erstarrt in photographischem Nachahmen des Äussern und in leblosen Stilimitationen. Wie ein einsames Gebirge ragt Goethes Faust-Phantasie in jene vernunftgläubige Epoche hinein. Als man ihn vorwurfsvoll fragte, wie sie denn zu verstehen sei, antwortete er: «Je inkommensurabler und für den Verstand unfasslicher eine poetische Produktion ist, desto besser!»

Dem allgemeinen Nützlichkeitsdenken und dem einseitigen Überwiegen des Verstandesmässigen entsprechend, fand das Irrationale immer weniger Ausdrucksmöglichkeit, denn auch die religiösen Formen waren allen Lebens bar. – Die Seele blieb

in die Unterwelt verbannt. Da sich aber die Mächte des Unbewussten nicht wegzaubern liessen, begannen sie, das Gebäude der Vernunft von innen her zu unterhöhlen. In der Kunst bildete sich eine Reaktion gegen das immer noch vorherrschende, alt und leblos gewordene Renaissance-Ideal: Um 1860 traten die Impressionisten auf. ‹Impressionismus› ist eine ganz uneigentliche Bezeichnung, die durch Zufall hängen blieb, weil ein ausgestelltes Bild ‹Impression› hiess. Sie selbst nannten sich ‹Divisionistes›, da sie die Erscheinung der äussern Welt in ihre Farbelemente aufteilten. Eine Gruppe der Divisionistes nannte sich sogar ‹Pointillistes›, weil sie ihre Darstellungen in rasterartige Farbpunkte auflösten. Die Impressionisten betonten ihre Uninteressiertheit am Inhalt der Bilder; wesentlich war ihnen das Teilgebiet der Farben. Dieser Zerlegungsprozess setzte sich weiter fort: Um die Wende zum 20. Jahrhundert erschien der Kubismus. Er löste Formen der äussern Erscheinung in ihre geometrischen Grundelemente auf. Von da war es nur ein Schritt zur abstrakten Kunst, die sich von äussern wie von innern Gegenständen losgesagt hat. Damit war ungefähr zur Zeit des Ersten Weltkrieges das traditionelle, ganzheitliche Idealbild der äussern Welt aufgelöst. Natürlich ist dieser Vorgang hier verallgemeinert und nur in den wichtigsten Hauptlinien beschrieben. In Wirklichkeit liefen vielerlei Strömungen nebeneinander her und überschnitten sich. Jung sagte von diesem Prozess, seine Essenz sei die Entwertung des Objekts. Die Kunst bilde ein Gegengewicht zur Tendenz eines Zeitalters.

Zur Entwertung einer zu extravertierten Kunst trug auch die Erfindung der Photographie bei. Diese noch mechanischere

Abbildung des Äussern, zusammen mit ihrer maschinellen Massenhaftigkeit, gab der geistentleerten naturalistischen Malerei vollends den Todesstoss. Mit der Entwertung und Auflösung des Bildes der äussern Welt war der Weg freigelegt zum innern Bild. Ohne diese Entwicklung hätte man sich wohl nicht vom überlebten Renaissance-Ideal zu befreien vermocht. Dies ist zu beobachten bei Künstlern des 19. Jahrhunderts, die sich in traditioneller Weise mit innern Motiven befassten, wie etwa Klinger, Böcklin oder Thoma. Ihre Malerei blieb in Allegorien befangen, welche ganz konkret, wie eine äussere Realität, dargestellt wurden.

Die Abwendung vom Äussern, welche die Pioniere der modernen Kunst hervorgebracht, war hoffnungsvoll und aussichtsreich. Aber konnte man nun den Zugang zum Innern finden? Kann man ihn finden, ohne eine positive Einstellung zur Psyche? Die Abwendung vom Äussern ist an sich noch keine Zuwendung zum Innern. Und die immer noch vorherrschende materialistische Einstellung aus dem 19. Jahrhundert mit ihrer Herabsetzung des Seelischen war wenig dazu angetan. Sie blockierte den Weg nach innen.

Im Zarathustra-Seminar beschrieb Jung[2], wie beim modernen Menschen die Zugänge zum Unbewussten verstopft seien, weshalb sich dieses mit Gewalt Luft mache und eine chaotische Lava herausschleudere. Dieser Ausbruch ist sichtbar geworden in verschiedenen Richtungen der neueren Kunst, wie zum Beispiel im Tachismus, der das noch Ungeformte, Gestaltlose abbildet. Das vulkanisch-gewaltsame Herausschleudern zeigt sich in jenem Verfahren, wo mit dem Gewehr auf gefüllte Farbgefässe geschossen wird, die dann ihren Inhalt auf die

Leinwand verspritzen. Oder es werden aufgetragene Farbmassen mit Benzin übergossen und angezündet, worauf das Feuer Löcher und bizarre Formen herausbrennt.

Solche, nach den Gesetzen des Zufalls entstandenen Bildungen mögen anregend sein für die Phantasie, doch können sie kaum allein genügen, um die Inhalte des Unbewussten auszudrükken. Dies aus dem ganz einfachen Grund, weil uns in Träumen und Phantasien oft sehr eindrucksvolle, ganzheitliche, deutlich ausgeformte Gestalten entgegentreten und sich in Szenerien, die durch Fremdartigkeit und grossen Reichtum ausgezeichnet sind, dramatische Handlungen ereignen. Jung sagte im Traum-Seminar[3]: «Man ist beeindruckt von der Tatsache, dass das Unbewusste des Menschen eine Art Spiegel grosser Dinge ist.» Aber materialistische Vorurteile, Zynismus und Angst verbauen den Zugang zum Innern nur zu oft, und die verbreitetsten Psychologien vermögen die darin verborgenen Werte nicht zu sehen oder betrachten sie als uneigentliche Sexualität und dergleichen; ein Einfluss, unter dem das Seelische nicht gedeihen kann.

Durch solche Haltungen entstand ein gefährlicher Zustand explosiver innerer Spannungen, indem das kollektive Unbewusste nirgends mehr richtig an das Leben angeschlossen war. «Es wird eine weltweite Umwälzung geben», prophezeite Jung[4] aus diesem Grunde schon vor Jahrzehnten, und es scheint uns, wir seien bereits mitten in diesem Zustand angelangt.

Oft hört man, das Chaos der heutigen Kunst sei ja eben gerade die Darstellung dieses innern chaotischen Zustandes. Aber selbst im Chaos zu versinken, ist keine Darstellung davon.

Dafür braucht es Abstand, einen festen Standpunkt des Bewusstseins ausserhalb und ein gestaltendes Eingreifen. Zudem ist das passive Verharren in der Auflösung etwas zu Negatives. Die Aufgabe bestünde, meines Erachtens, eher darin, in dieser formlosen Masse der ‹chaotischen Lava› die Anzeichen einer neuen Ordnung zu suchen. Insgeheim herrscht bereits eine grosse Sehnsucht, über das Auflösende hinauszugelangen. Bei richtiger Einstellung kann man sich von der Strömung des Unbewussten ergreifen lassen, ohne den eigenen Standpunkt zu verlieren; man kann das Wertvolle überhaupt nur so erkennen und festhalten. Das andringende geistige Material muss ja beobachtet und ausgewählt werden können. Was wäre ein Traum, wenn ihm kein wahrnehmendes, bewusstes Ich gegenüberstünde?

Die grosse Gefahr, in die viele Menschen geraten sind durch den Verlust der Religion, durch den Unterbruch einer Verbindung mit den Tiefen des Unbewussten, beschrieb Jung im Zarathustra-Seminar[5] folgendermassen: «Das ist es, was die Leute nicht wissen: dass sie nackt dem Unbewussten ausgesetzt sind, wenn sie nicht länger mehr die alten Wege benützen können ... Sie sind schutzlos und müssen ihr Unbewusstes unterdrücken. Sie können es nicht ausdrücken, weil es unausdrückbar geworden ist ...» Das Unbewusste ist unausdrückbar geworden für die im Rationalismus Gefangenen, welche sich alle Wege dazu verbaut haben.

Der heutige Künstler hat also allen Grund, für sich und seine Mitmenschen einen Zugang zum Innern zu suchen, gewissermassen ein Ventil zu bilden oder ein Gefäss zu sein, um das von dort Andringende aufzunehmen. Er muss versuchen, die

seelischen Mächte in Bilder zu fassen. Dazu gehört auch die Erfahrung, dass ihm aus der Psyche etwas Lebendiges, Selbständiges entgegentritt.

So träumte es einem Maler, ein riesiger wilder Jäger in grünem Kleide – eine Wotan ähnliche Gestalt – dringe in seine Werkstatt ein und verlange, gemalt zu werden. Hier stellt sich deutlich die selbständige Aktivität der Figuren des Unbewussten dar, wie sie den Menschen aufsuchen, um gesehen und festgehalten zu werden. Und jemandem träumte es, er befinde sich in einem endlosen, labyrinthisch verschlungenen Höhlensystem. Er wusste, dass darin auch ein anderer lebte, eine mächtige, halb tierisch, halb göttliche Gestalt, die *ihn* suchte. Er fürchtete sich vor diesem Wesen, floh vor ihm und war zugleich von ihm angezogen. Hier hat sich der schöpferische Dämon des Unbewussten abgebildet, wie er die Berührung mit dem Menschen begehrt, wie er ihn auf langen, verschlungenen Wegen verfolgt. Er ist wie der unsterbliche, göttliche Bruder beim Dioskurenpaar.

Diese Macht kann aber auch zum zerstörenden Dämon werden, wenn sie immer verleugnet und vom Leben ausgeschlossen wird. Ein begabter Mann, der aber in Gefahr war, die Inhalte des Unbewussten zu egoistischen Zwecken zu benützen, träumte von jemandem, der ein riesiges, uraltes, unterirdisches Gewölbe entdeckt hatte, das ganz mit goldgelbem Honig gefüllt war. Er drang dort ein und öffnete das Tor, worauf der Honig mit solcher Wucht herausströmte, dass der Begierige darin ertrank. Der Träumer selbst stieg dann ebenfalls in den Raum hinab, um die Beute einzubringen, wurde aber dort vom Teufel überrascht und konnte sich nur durch einen Kampf auf

Leben und Tod erretten. In diesem Traume zeigt sich, wie der im Unbewussten verborgene Wert auch zum Unheil werden kann. Die Möglichkeit des Missbrauchs ruft den Teufel auf den Plan.

Ausserordentlich eindrucksvoll ist es immer, wie das Unbewusste selbst zu diesen Problemen Stellung bezieht und auf den individuellen Fall abgestimmt reagiert. Im Traum schildert es die jeweilige Lage, die dem Bewusstsein oft so dunkel ist: Einmal inspirierend, ermutigend, bestärkend, dann wieder kritisierend, warnend oder ablehnend.

Einer Frau, die vor einer schöpferischen Aufgabe stand und Ermutigung brauchte, träumte es, ihr Garten hänge voller reifer, goldfarbener Äpfel. Hier ist das Produzieren dargestellt als ein Ernten eines Wertvollen, das im Unbewussten herangereift ist. Umgekehrt träumte es jemandem, der sich vor seiner geistigen Aufgabe drückte, die Früchte seines Gartens verfaulten, weil er es versäume, sie zu pflücken. Ein Mann, der sich seiner geistigen Möglichkeiten noch gar nicht bewusst war, träumte, er entdecke in seinem Keller einen wunderbaren, fremdartigen, reich geschmückten Schatzkasten. Und oft erscheint in Träumen das Motiv des grossen Hauses, in dem noch unbekannte Räume voll kostbarer Dinge gefunden werden. Einer Frau, die nach langer Analyse zuletzt selbst Analytikerin wurde, träumte es schon viele Jahre zuvor, sie entdecke in einer unterirdischen Höhle eine Heilquelle, deren Fassung eine lange und geduldige Arbeit erfordere. Jemand, mit einer schriftstellerischen Arbeit beschäftigt, war in den Fehler verfallen, sich ironisch über einen ernsthaften Gegenstand zu äussern. Ihm träumte, eine grosse Künstlerin, eine Malerin mythi-

scher Phantasien, sei gestorben, weil in zynischer Weise über ihre Bilder geschrieben worden sei. Dieser Traum liess den Schriftsteller gewahr werden, dass die Künstlerin in ihm stirbt, wenn sein Bewusstsein den Bildern des Unbewussten gegenüber eine unernste Haltung einnimmt.

Alle die genannten Traumbilder zeigen deutlich, wie das Mächtigere, das Überlegene und das Kostbare im Unbewussten liegen kann, und das Ich dabei der Empfangende ist. Sie lassen auch erkennen, wie das Ich eine richtige, bescheidene Einstellung braucht, damit es etwas von jenen Schätzen bekommt, und dass es den Willen aufbringen muss, Anstrengungen und Opfer auf sich zu nehmen. Es ist wie in den Märchen, wo der Held dienen und sich unterordnen muss. Er hat alle möglichen Ansprüche zu opfern und oft mühselige und gefährliche Arbeiten zu verrichten, bis ihm die ersehnte Kostbarkeit zufällt. So könnte es vielleicht für den heutigen Künstler die geforderte Mühe sein, eine neue, der Epoche entsprechende Ausdrucksweise zu erarbeiten, die den Inhalten des Unbewussten gerecht wird. Es ist ein Ringen darum, das beinahe Undarstellbare sichtbar zu machen. Je ernster der Maler das innere Bild nimmt, desto grösser wird sein Wunsch nach bestmöglicher Gestaltung werden.

Als um die Jahrhundertwende die moderne Kunst sich von aller Tradition abwenden musste, lösten die Künstler sich auch von der traditionellen handwerklichen Technik. Das überlieferte Darstellenkönnen, erlernt mit grosser Arbeit durch minuziöse Ausbildung in figürlichem Zeichnen, Perspektive usw., war nicht an sich verwerflich. Es war eher der Missbrauch abzulehnen, den die naturalistische Kunst des 19. Jahrhunderts

damit getrieben hat. All dieses ererbte Gut, dieses Wissen und Können aufzugeben, könnte fragwürdig erscheinen. Und doch ist es nicht zu übersehen, dass es das Ausdrucksmittel einer immer einseitiger, extravertiert gewordenen Kunst war – in geradezu naturwissenschaftlicher Weise zugespitzt –, um jede Einzelheit des Äussern zu erfassen. Die Gefahr dieser klassischen Technik liegt darin, dass damit dargestellte innere Gegenstände zu sehr auf die Seite des Stofflichen gezogen und dadurch verfälscht werden könnten. Andrerseits scheint es auch noch keine befriedigende Lösung darzustellen, sich mit den beschriebenen modernen Zufallsbildungen und Formlosigkeiten zu begnügen, wie sie etwa durch Gerinnung von Farben entstehen. Das wäre ungefähr, wie wenn man sich mit dem Finden einer originell gewachsenen Wurzel als Ausdruck des Unbewussten zufriedengäbe. Vermutlich sind solche Anregungen der Phantasie erst die Basis – etwas wie die Prima materia –, aus der dann das Wertvolle in mühsamer Arbeit herausdestilliert werden muss.

Aus dem, was ich bis dahin zu schildern versuchte, geht hervor, dass heute die Kunst nicht mehr als eine bloss ästhetische Frage angesehen werden kann. Sie ist nicht ein Selbstzweck nach dem Motto ‹L'art pour l'art›, sondern muss wieder als eine Hilfe betrachtet werden, neuen, unbekannten, drängenden seelischen Inhalten Ausdruck zu verschaffen. Das Ich muss sich dabei als das Empfangende verhalten können, was eine religiöse Einstellung erfordert, Religion im Sinne von sorgfältiger Beobachtung und Berücksichtigung psychischer Faktoren.

Während die alte religiöse Kunst Bilder allgemein sanktionierter, dogmatischer Vorstellungen brachte, steht der heutige

Künstler mit seinen Erlebnissen allein, allen Irrtümern preisge-
geben. Jung schrieb in ‹Psychologie und Religion›[6]: «Ein
Dogma ist immer das Resultat und die Frucht von vielen
Geistern und vielen Jahrhunderten. Es ist gereinigt von allem
Bizarren, von allem Unzulänglichen und Störenden der indivi-
duellen Erfahrung. Aber trotz alledem ist die individuelle
Erfahrung gerade in ihrer Armseligkeit unmittelbares Leben,
sie ist das warme, rote Blut, das heute pulsiert. Sie ist einem
Wahrheitssucher überzeugender als die beste Tradition.» Mit
dieser Art individuellen Erlebens ist wieder etwas wie ein
Urzustand hergestellt, da individuelle Visionen die innere Welt
enthüllen. Es ist ein Neu-Anfang.

Jung hat sich vor allem als Arzt gesehen, aber es ist immer
deutlicher geworden, dass er nicht nur einzelne Kranke heilte,
sondern zum Arzt seines ganzen Zeitalters wurde. Indem er
vielen Menschen dazu verhalf, eine Beziehung zur produkti-
ven, führenden und ordnenden Seite der Seele zu bekommen,
stellte er das Problem des psychischen Leidens in viel weitere
Zusammenhänge. Dieses Leiden wurde dadurch weniger eine
Krankheit als ein Abgeschnittensein vom Wesentlichen und
von der eigenen Bestimmung. Diese Tat entreisst den heutigen
Menschen der trostlosen und aussichtslosen Enge der materia-
listischen Weltanschauung und verschafft ihm die Möglichkeit,
selbst die Tätigkeit jener schicksalshaften Macht zu erfahren,
die seinem Leben einen eigenen Sinn verleiht.

In der Atmosphäre des Rationalismus kann das Psychische
nicht leben; er ist wie ein Stein, der auf der Pflanze liegt, auf
jenem eigenwilligen schöpferischen Keim, der sich aus der
Seele entfalten möchte. Jung hat ihn von dieser Last befreit. Er

hat jenen geistigen Trieb des Unbewussten nicht nur theoretisch beschrieben, sondern auch die Beispiele seiner Tätigkeit gezeigt und das eigene Leben durch ihn gestalten lassen.

Damit kann Jung wohl ein Leitbild sein für den heutigen Künstler, der einen Weg sucht zur Schatzkammer seiner Seele. Von jenem kostbaren Behältnis schrieb er das schöne und tröstliche Wort[7]: «Es scheint mir, es sei nichts Wesentliches je verlorengegangen, denn seine Matrix ist ewig gegenwärtig in uns, und von dieser kann und wird es wieder hervorgebracht werden, wenn nötig.»

Vortrag, gehalten an der C.-G.-Jung-Gedenkfeier am 6. Juni 1970 in Zürich.

Literatur
1 Jung, C.G.: Dream Symbols of the Individuation Process. Seminar held at Bailey Island, Maine 1936, p.83. Private Copyright.
2 Jung, C.G.: Psychological Analysis of Nietzsche's Zarathustra. Notes on the seminar, vol.2, p.208. Zürich 1934. Private Copyright.
3 Jung, C.G.: Dream Analysis. Seminar on Analytical Psychology, 3rd ed., vol.2, p.116. Zürich 1929–1930. Private Copyright, 1958.
4 Jung, C.G.: Interpretation of Visions. Seminar on Analytical Psychology, part 8, p.92. Zürich 1933.
5 Jung, C.G.: Psychological Analysis of Nietzsche's Zarathustra. Notes on the Seminar, vol.9, p.33. Zürich 1938. Private Copyright.
6 Jung, C.G.: Psychologie und Religion, p.92. Rascher, Zürich 1947.
7 Serrano, M.: C.G. Jung and Hermann Hesse, p.86. Routledge & Kegan Paul, London 1966.

BILDVERZEICHNIS

1 Nachtfalter, Aquarell und Buntstift, 1944/45
2 Der Gespaltene, Öl, Januar 1953
3 Die Katze, Öl, zwischen 1949 und 1955
4 Depression, Öl, 1954/55
5 Der Aufsteigende, Öl, etwa 1954/55
6 Der Einwärtsblickende, Öl, 1954/55
7 Die vierte Dimension, Öl, 1956/57
8 Tier im Berg, Öl, etwa 1958
9 Feuergeburt, Öl, 1959/60
10 Der Ausgestossene, Öl, 1960
11 Puer, Öl, April 1960
12 Zwillingsfisch, Öl, 1961
13 Geburt aus dem Jenseits, Öl, 1961
14 Der geheime Herrscher, Öl, Mai–Juni 1964
15 Moira, Öl, 1965
16 An der Tür, Öl, August–September 1965
17 Schwangere, Öl, Januar 1966
18 Anima mit Lichtkrone, Öl, September 1966
19 Der Beobachter, Öl, 1966
20 Bär am Lichterbaum, Ölkreide, 1968
21 Schildkrötenmann, Ölkreide, etwa 1968
22 Das Fenster zur Ewigkeit, Ölkreide, August 1970
23 Die Weisse Frau, Öl, März 1971
24 Der 24. März 1971, Öl, 1971
25 Gottesfeuer, Öl, Juni–September 1974
26 Zwiegespräch, Öl, April 1975
27 In der Nacht vom 13. Oktober 1942, Öl, September 1975
28 Naturgeist, Öl, Juni 1976
29 Luchs, Öl, September 1976
30 In Gottes Hand, Lithographie, 1975
31 Zweikampf, Lithographie, 1973
32 Vieräugiger Weltgeist, Lithographie, 1975
33 Sternbrunnen, Lithographie, 1974
34 Spiritus Animalis I, Lithographie, 1972
35 Schmetterlingsgeburt, Lithographie, 1976
36 Feuertänzerin, Lithographie, 1975
37 Isis, Lithographie, 1976
38 Porträt von C. G. Jung, Kreide, April 1958
 Der Beobachter, Lithographie, 1975 (Buchrückseite)

LIST OF PLATES

1 Moth, watercolour and crayon, 1944/45
2 The World's Wound, oil, January 1953
3 The Cat, oil, between 1949 and 1955
4 Depression, oil, 1954/55
5 Coming Up, oil, ca. 1954/55
6 The Inward Gaze, oil, 1954/55
7 The Fourth Dimension, oil, 1956/57
8 Imprisoned Power, oil, ca. 1958
9 Fire Gives Birth, oil, 1959/60
10 The Outcast, oil, 1960
11 Puer, oil, April 1960
12 The Magic Fish, oil, 1961
13 A Birth, oil, 1961
14 The Hidden Power, oil, May–June 1964
15 Moira, oil, 1965
16 At the Door, oil, August–September 1965
17 With Child, oil, January 1966
18 Anima with Crown of Light, oil, September 1966
19 The Observer, oil, 1966
20 Bear at the Tree of Light, crayon, 1968
21 Spiritus Animalis II, crayon, ca. 1968
22 Window on Eternity, crayon, August 1970
23 The Woman with the Cup, oil, March 1971
24 24 March 1971, oil, 1971
25 Lighting the Torch, oil, June–September 1974
26 Having Speech, oil, April 1975
27 In the Night of 13 October 1942, oil, September 1975
28 Spiritus Naturae, oil, June 1976
29 Lynx, oil, September 1976
30 In His Hands, lithography, 1975
31 Duel, lithography, 1973
32 The Fourfold Face, lithography, 1975
33 Constellation, lithography, 1974
34 Spiritus Animalis I, lithography, 1972
35 Birth from the Chrysalis, lithography, 1976
36 The Flame Dancer, lithography, 1975
37 Isis, lithography, February 1976
38 Portrait of C. G. Jung, chalk, April 1958
 The Observer, lithography, 1975 (back cover)